KING CHARLES III

100 moments from his journey to the throne

Compiled by Sam Carlisle

This book is dedicated to Ann Edwards, beloved wife of Arthur.

Published by HarperCollins*Publishers*

HarperCollins*Publishers*
Westerhill Road, Bishopbriggs
Glasgow G64 2QT
HarperCollins Publishers

HarperCollins*Publishers*
Macken House, 39/40 Mayor Street Upper, Dublin 1,
D01 C9W8, Ireland

A catalogue record for this book is available
from the British Library.

ISBN 978-0-00-862930-4

10 9 8 7 6 5 4 3 2 1

Printed in the United Kingdom.

ACKNOWLEDGEMENTS

Arthur, thank you for supporting this project and for being such a
hard-working and kind colleague over the years.
Thank you to The Sun's Amy Reading for diligent and creative
picture research, as always.
Without the team in the News UK Information Services
department this book would have taken years. Thank you Steve
Baker, Chris Ball, Lee Chilvers, Sue De Friend, Michael-John
Jennings and Chris Whalley.
Craig Balfour, Harley Griffiths, James Hunter and Amy Townsend-
Kennedy at HarperCollins Publishers, you are a dream team.
Thanks also to Will Hagerty, Simon Cosyns, Richard Barun and
Tony Brannon for your oversight and guidance and to all The Sun
royal reporters who have trodden this beat.
And to Jenna Sloan for sharing research and holding the fort.

IMAGES

Dust jacket front © Arthur Edwards/News Group Newspapers Ltd; dust jacket
back (l) ullstein bild - RDB / Getty Images, (m) Arthur Edwards/News Group
Newspapers Ltd, (r) © REUTERS / Alamy Stock Photo; hardcover front ©
Arthur Edwards/News Group Newspapers Ltd, hardcover back © Arthur
Edwards/News Group Newspapers Ltd; P6 © Shutterstock; P9 © The Print
Collector / Alamy Stock Photo; P10 © SuperStock / Alamy Stock Photo;
P12 © PA Images / Alamy Stock Photo; P14 © PA Images / Alamy Stock
Photo; P17 © PA Images / Alamy Stock Photo; P18 © PA Images / Alamy
Stock Photo; P19 © Keystone Press / Alamy Stock Photo; P21 © ullstein bild
- RDB / Getty Images; P23 © Keystone Press / Alamy Stock Photo; P24(a) ©
Keystone Press / Alamy Stock Photo; P24(b) Peter Jolly / Shutterstock; P26
© Keystone / Getty Images; P27 © Paul Popper/Popperfoto / Getty Images;
P28 © PA Images / Alamy Stock Photo; P31 © PA Images / Alamy Stock
Photo; P33 © PA Images / Alamy Stock Photo; P35 © PA Images / Alamy
Stock Photo; P36 © PA Images / Alamy Stock Photo; P39 © Trinity Mirror /
Mirrorpix / Alamy Stock Photo; P40(a) © PA Images / Alamy Stock Photo;
P40(b) © PA Images / Alamy Stock Photo; P43 © AFP / Getty Images; P44
© Serge Lemoine / Getty Images; P47 © Fox Photos / Getty Images; P48
© Trinity Mirror / Mirrorpix / Alamy Stock Photo; P49 © Trinity Mirror
/ Mirrorpix / Alamy Stock Photo; P51 © Mirrorpix / Getty Images; P53 ©
Trinity Mirror / Mirrorpix / Alamy Stock Photo; P55 © The Fincher Files/
Popperfoto / Getty Images; P56 © GRANGER - Historical Picture Archive /
Alamy Stock Photo; P58 © Arthur Edwards / News Group Newspapers Ltd;
P59 © James Gray/Daily Mail/Shutterstock; P61 © Arthur Edwards / News
Group Newspapers Ltd; P62 © Bettmann / Getty Images; P63 © PA Images /
Alamy Stock Photo; P64 © Shutterstock; P65 © Tim Graham / Getty Images;
P66 © Tim Graham / Getty Images; P67 © Arthur Edwards / News Group
Newspapers Ltd P68(a) © Tim Graham / Contributor / Getty Images; P68(b)
© Keystone/Shutterstock; P70 © Tim Graham/Getty Images; P72 © Tim
Graham / Getty Images; P73 © AP/Shutterstock; P75 © Jorgensen/Carraro/
Young/Shutterstock; P76 © Shutterstock; P78 © Northcliffe Collection/ANL/
Shutterstock; P80(a) © parkerphotography / Alamy Stock Photo; P80(b) ©
Panther Media GmbH / Alamy Stock Photo; P81 © Jenny Goodall/ANL/
Shutterstock; P82 © NJ/Shutterstock; P84 © PA Images / Alamy Stock Photo;
P85 © Joe Schaber/AP/Shutterstock; P87 © Anwar Hussein / Getty Images;
P88 © PA Images / Alamy Stock Photo; P89 © Tim Graham/Getty Images;
P91 © David Hartley/Shutterstock; P93(a) © PA Images / Alamy Stock
Photo; P93(b) © Shutterstock; P94 © Mike Forster/Daily Mail/Shutterstock;
P97 © Shutterstock; P98 © Shutterstock; P99 © ITV/Shutterstock; P100
© Shutterstock; P103(a) © Shutterstock; P103(b) © Shutterstock; P105(a)
© Shutterstock; P105(b) © Laurent Rebours/AP/Shutterstock; P107(a) ©
Times Newspapers/Shutterstock; P107(b) © Shutterstock; P109 © Trinity
Mirror / Mirrorpix / Alamy Stock Photo; P111 © Arthur Edwards/News
Group Newspapers Ltd; P112 © Arthur Edwards; P113 © Tim Graham/Getty
Images; P115 © PA Images / Alamy Stock Photo; P116 © Shutterstock; P117
© UK Press/Getty Images; P119 © Shutterstock; P120 © Shutterstock; P123
© PA Images / Alamy Stock Photo; P125 © Shutterstock; P126 © Tim Rooke/
Shutterstock; P127 © Shutterstock; P129(a) © Serge Lemoine / Getty Images;
P129(b) © Michael Fresco/Shutterstock; P129(c) © Steve Wood/Shutterstock;
P129(d) © Hugo Burnand/PA/Shutterstock; P131 © Shutterstock; P133 ©
Shutterstock; P134 © Shutterstock; P137 © Jonathan Short/AP/Shutterstock; P137 © Shutterstock;
P138 © Tim Rooke/Shutterstock; P140 © Shutterstock; P142 © Tim Rooke/
Shutterstock; P144 © Arthur Edwrds / News Group Newspapers Ltd; P147(a)
Arthur Edwards; P147(b) Arthur Edwards / News Group Newspapers Ltd;
P149 © Shutterstock; P150 © Stan Pritchard / Alamy Stock Photo; P153 ©
Arthur Edwards; P154 © PA Images / Alamy Stock Photo; P156 Chris Jackson
/ Getty Images; P158 © Dan Charity - The Sun; P160 © WPA Pool / Getty
Images; P162 © Sefano Spaziani/UPI/Shutterstock; P163 © Shutterstock;
P164 © Shutterstock; P165 © Tim Rooke/Shutterstock; P166 ©Shutterstock;
P167 © Arthur Edwards / News Group Newspapers Ltd; P169 © WPA Pool
/ Getty Images; P170 © snapshot-photography/F Boillot/Shutterstock; P171
© Jonathan Brady/PA Wire/Shutterstock; P172 © Arthur Edwards / NEWS
UK; P175(a) © Tim Rooke/Shutterstock; P175(b) © Leon Neal/WPA Pool/
Shutterstock; P176 © Chris Jackson/AP/Shutterstock; P177 © David Fisher/
Shutterstock; P178 © Owen Humphreys/WPA Pool/Shutterstock; P181 ©
Toby Melville/WPA Pool/Shutterstock; P182 © Tim Rooke/Shutterstock;
P185(a) © Stephen Lock/i-Images/Shutterstock; P185(b) © Arthur Edwards/
News Group Newspapers Ltd; P186(a) © WPA Pool/Getty Images; P186(b) ©
Yui Mok/WPA Pool/Shutterstock; P188 © PA Images / Alamy Stock Photo;
P189 © Arthur Edwards/WPA Pool/Shutterstock; P190 © Victoria Jones/
WPA Pool/Shutterstock; P192 © Victoria Jones/WPA Pool/Shutterstock.

CONTENTS

THE KING & I:
FOREWORD BY ARTHUR EDWARDS MBE

When *Sun* Editor Larry Lamb offered me the job of Royal Photographer in the late 70s, I wasn't interested. I reluctantly accepted, because in those days you didn't say no. Boy, am I glad I did.

That decision drew me into the orbit of Prince Charles. It allowed me to photograph this extraordinary individual for more than 40 years and to capture many of the moments that made the man who is now our King.

We have never had a monarch more prepared for the role than Charles. He has spent 70 years as heir apparent, thinking deeply about how to improve the world, serving in the military, making hundreds of connections and becoming a loving father and grandfather.

Many of his beliefs that were considered cranky have become mainstream – you can't move in supermarkets now for organic food.

His sense of duty is matched only by his deep interest in people, in the UK and around the world. His capacity for hard work is remarkable.

He has an ability to make change happen against the odds, as with his phenomenal charity The Prince's Trust.

I have been on tours where he has noticed a community needs a school. He returned home, raised money, and got that school built without fuss or fanfare.

On a visit to the White House, Charles pointed at me and said: "This man has followed me for, how long?"
I said: "37 years, sir." Smiling President Obama said: "That's awesome."

As a Catholic, Charles gave me the greatest gift – arranging for me to meet Pope Francis.

I am regularly at Sandringham on Christmas Day. Last Christmas I was photographing Charles as King for the first time.

He said: "It's very kind of you to take time to be here, Arthur."

"Sir," I said, "You have done more for me than anyone, I wouldn't be anywhere else."

I was the last photographer to portray him as a Prince – giving a *Sun* award at Dumfries House, Scotland, the night before Her Majesty the Queen died – and the first to photograph him arriving in England as King.

This book is a tribute to Charles as we celebrate the historic occasion of his Coronation. I hope you enjoy some of my favourite photographs of this remarkable man.

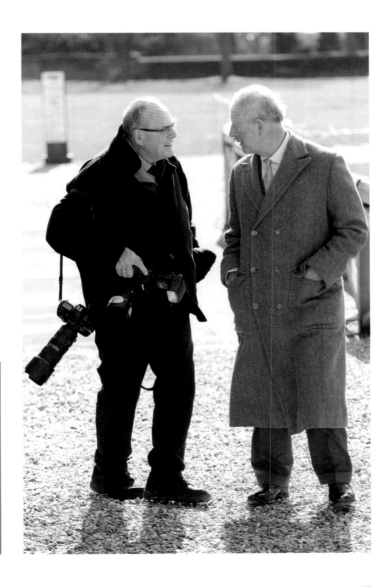

Arthur Edwards MBE and Charles in conversation at Tattershall Castle, Lincolnshire in 2018. Arthur has followed Charles around the world, snapping the Royal since the 1970s.

PRINCESS AND A LITTLE PRINCE

NOVEMBER 14, 1948

Like a scene from a fairytale, Princess Elizabeth gazed adoringly at her baby son – England's future king.

Both were destined for greatness as the first and second in line to the throne but for a moment they were simply mother and newborn son.

Just three years after the end of World War II, the birth of Prince Charles Philip Arthur George symbolised a new, modern Britain and Commonwealth and hope for the decades ahead.

Of course tradition still marked the royal birth – the King's Troop Royal Artillery fired a 41 gun salute, the bells of Westminster Abbey rang and crowds outside the Palace celebrated the happy, historic news.

This intimate portrait was taken by Vogue photographer Cecil Beaton, and showed the Duchess of Edinburgh adjusting to motherhood before the excitement of the baby's christening on December 15 at Buckingham Palace.

Beaton said: "His mother sat by the cot and, holding his hand, watched his movements with curiosity, pride and amusement."

On the evening of Charles's birth in the Buhl Room at the Palace, Prince Philip and the King and Queen waited in an adjoining room and were first to hear the news.

At 10pm a court circular announced: "The Princess Elizabeth, Duchess of Edinburgh, was safely delivered of a prince at 9.14pm today. Her Royal Highness and her son are both doing well."

Large crowds who had gathered near the Victoria Memorial were informed of the birth after a servant of the Royal Household crossed the forecourt to the gates. He told a policeman, who then relayed the news to the waiting well-wishers.

A loud cheer of "Good old Prince Philip!" went up.

Inside the palace, the Duke of Edinburgh was first to see his wife, then immediately went into the nursery where his son had been placed in a crib.

King George and Queen Elizabeth then

met their grandson. The Queen gave the baby a cuddle and the King shook his hand.

Later, the Duke of Edinburgh opened a bottle of champagne to share with staff and attending doctors, to wet the baby's head.

News of the royal birth spread across the world in minutes with radio stations and wires announcing the arrival of the Prince.

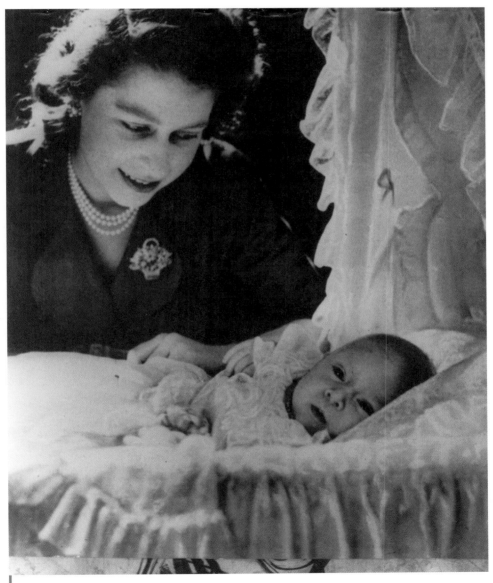

Princess Elizabeth gazes adoringly at her son Charles in their first portrait.

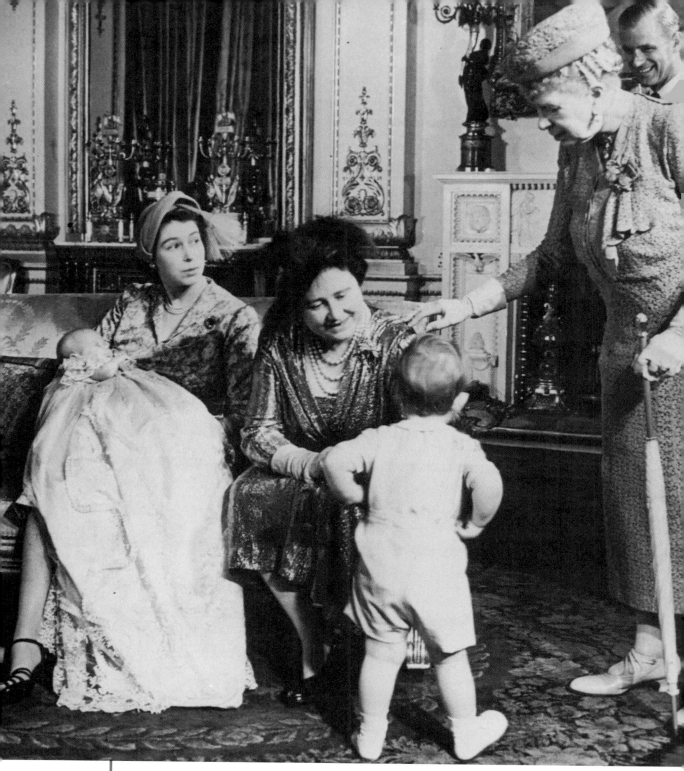

Charles upstages Anne at her christening. The siblings'
personalities were very different but they grew incredibly close.

CHARLES IN BIG BOTHER AT SISTER'S CHRISTENING

OCTOBER 21, 1950

Granny, look at me!

Prince Charles stole the show from his baby sister by messing about during the official photoshoot for her christening.

His grandmother, Queen Elizabeth and great grandma, the Queen Mother Queen Mary, patiently attempted to settle the restless toddler, while his mother cradled her daughter. But the fair-haired Prince, not yet two, kept wriggling away from them.

Princess Anne's christening took place in the Music Room at Buckingham Palace.

The nine-week-old royal baby wore the same Honiton Lace Robe that Charles wore for his christening. The robe was designed in 1841 for Queen Victoria's eldest child.

Charles's antics were witnessed by his grandfather, King George VI, and Anne's godparents – Earl Mountbatten (uncle of the Duke of Edinburgh), Countess of Athlone, Princess Margarita, Princess of Hohenlohe-Langenberg (sister of Prince Philip, the Duke of Edinburgh) and The Hon Andrew Elphinstone (Princess Elizabeth's cousin). The photographer was Cecil Beaton.

Anne Elizabeth Alice Louise was born on August 15, weighing 6lb. On the night, proud father Prince Philip declared: "It's the sweetest girl."

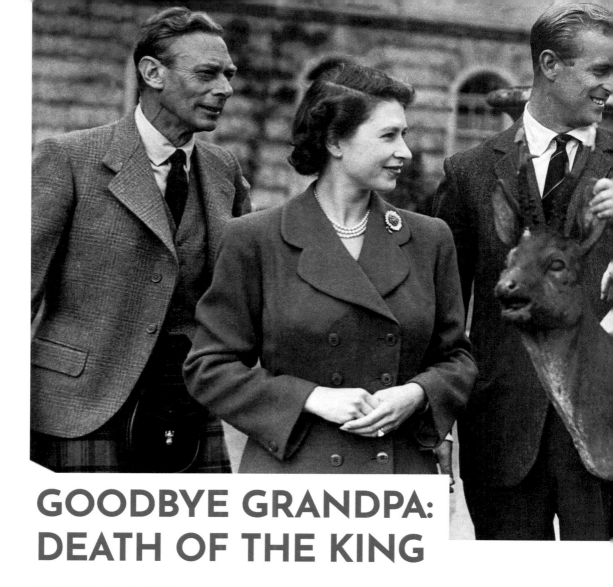

GOODBYE GRANDPA: DEATH OF THE KING

FEBRUARY 6, 1952

His Majesty King George VI died peacefully in his sleep in the early hours of February 6, 1952.

The announcement came from Sandringham at 10.45am, where the King was found by a valet. It said: "The King, who retired to rest last night in his usual health, passed peacefully in his sleep early this morning."

The King was 56. It had been 136 days since he had a lung operation.

With him at Sandringham were his wife, the Queen, daughter Princess Margaret, granddaughter Princess

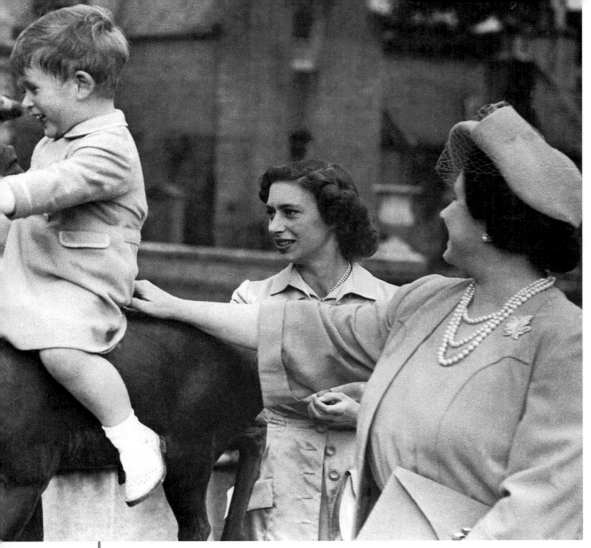

George VI, Princess Elizabeth, Prince Philip, Princess Margaret and the Queen watch Charles play on a statue at Balmoral in 1950.

Anne, 18 months, and grandson Prince Charles, three.

Charles became heir apparent on the accession of his mother to the throne.

Princess Elizabeth was in Kenya when the news was broken to her by Prince Philip. She flew home immediately.

The Queen Mother took Charles to one side later in the day to tell him the upsetting news.

When she explained a valet had been taking a cup of tea to the King when he found him, the concerned Prince enquired: "But who drank the tea?"

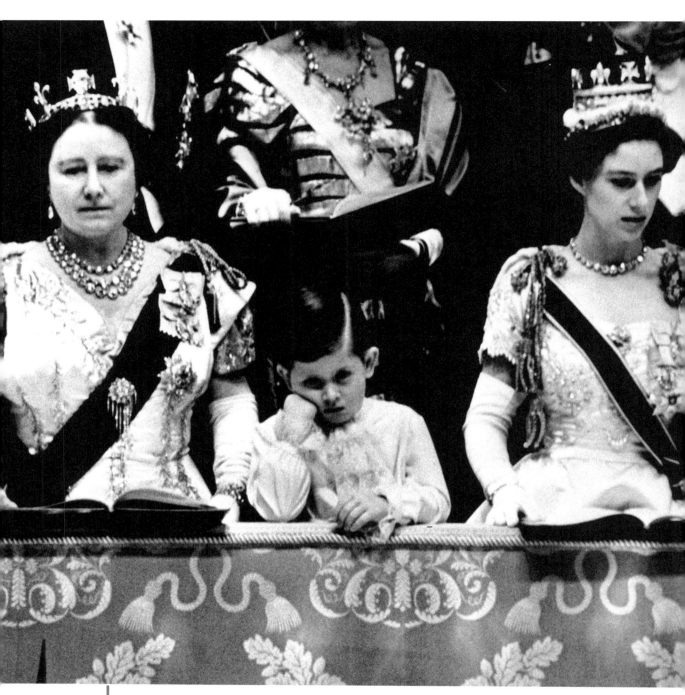

Prince Charles attends his mother's coronation alongside the Queen Mother and Princess Margaret.

CORONATION TREAT

JUNE 2, 1953

Young Prince Charles caused chaos on the day of his mother's coronation when he picked up the priceless Imperial State Crown.

The new Queen had removed the heavy headpiece after the ceremony when Charles, four, terrified her ladies-in-waiting by heading straight to it to play with.

Lady Anne Glenconner, an attendant to Her Majesty for the occasion, said: "The Queen took it off, put it on a table and Prince Charles made a beeline for it.

"We thought he was going to drop it. We thought, 'Oh my goodness, that would be a bad omen.' But luckily, I think my mother, as a lady-in-waiting, seized it from him and took it away."

The Imperial State Crown contains 2,868 diamonds, 269 pearls, 17 sapphires and 11 emeralds. It was created for the coronation of Charles's grandfather, George VI.

The young Prince may have been tempted because he had seen the Queen practise wearing the crown around Buckingham Palace before her big day.

She amused her children by popping into their bath time with it on her head.

Charles made British history by becoming the first child treated to the sight of his mother's coronation in person.

He received a special, hand-painted, child-friendly invitation to the ceremony.

The Prince appeared bored at moments in the three-hour service at Westminster Abbey. Stood between the bejewelled Queen Mother and his glamorous aunt, Princess Margaret, he curled his right fist into a ball and propped his cheek on it, looking glum.

Charles perked up later when his sister, Anne, three, joined him at Buckingham Palace for the Royal Air Force flypast over The Mall.

With his mother's accession to the throne, Charles became the Duke of Cornwall and inherited the Scottish titles Duke of Rothesay, Earl of Carrick, Baron of Renfrew, Lord of the Isles, and Prince and Great Steward of Scotland.

The coronation was broadcast live on TV and was watched by 27 million people in the UK, while 11 million listened on radio.

ONE IS SAILING

APRIL 14, 1954

Pointing at the Plymouth crowd, Prince Charles and Princess Anne set off on the Royal Yacht Britannia from England to meet their parents in Libya.

The newly crowned Queen Elizabeth and Prince Philip had been on a five-month tour of the Commonwealth without their children.

Charles, five, and Anne, three, were accompanied by nannies Mabel Anderson and Helen Lightbody.

The Prince had learned to live with long separations from his mum and dad as they carried out royal duties.

As heir apparent, Princess Elizabeth left her son in the care of nannies and his grandmother, the Queen, to undertake official tours or to spend time with her husband, a commander in the Royal Navy throughout the first two years of Charles's life.

From 1949 to 1951 the couple lived in Malta at the Villa Guardamangia, while Philip was second in command of HMS Chequers, then commander of HMS Magpie, part of the Mediterranean Fleet.

As King George VI's health deteriorated, his daughter's duties increased. In 1951 alone, she visited Italy, toured the UK, attended the Festival of Britain and helped host state visits from the royal families of Denmark and Norway. She also spent six weeks away from her children on a tour of Canada.

They returned from that last trip on the ocean liner the Empress of Scotland, via Liverpool – where the Princess signalled the first ever peel of the bells of the city's Cathedral – before taking the train to Euston. There Charles, who celebrated his third birthday while his parents were away, waited excitedly with the Queen.

Princess Elizabeth patted her son on the shoulder before shaking hands with waiting dignitaries, Charles in tow.

The Prince had grown very close to his grandmother and nannies, particularly Scot Mabel Anderson who had been in the royal service since just before Charles's birth.

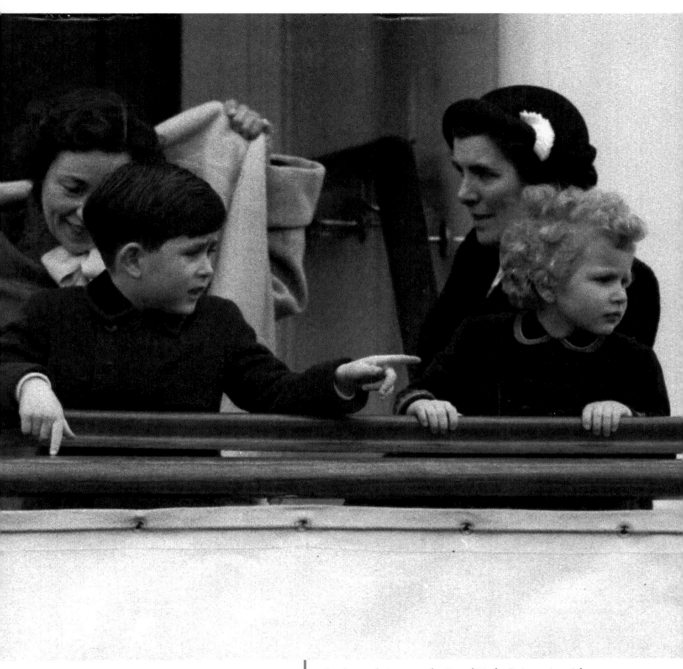

Charles and Anne on the Royal Yacht Britannia with nannies Mabel Anderson and Helen Lightbody.

A WINNING WINDSOR

JULY 8, 1957

Eight-year-old Charles plays a mix of netball and rugby as his father, mother and sister watch from the stands.

Go on one's son!
The Queen attended her boy's first sports day and watched him compete with classmates.

Commentators described the experiment to send Prince Charles to Hill House Prep School, and mix with other boys his age, as "very successful".

Every previous heir to the throne had been taught by tutors at home.

After ten months at the private day school in Knightsbridge, the Prince certainly looked comfortable charging about with his friends in the sunshine at the Duke Of York's Headquarters, used by Hill House for sport.

More formal was Charles, Duke of Cornwall, presenting fellow pupils to his mother in a line up. The seven- and eight-year-old boys were expected to shake hands with the monarch and then with Prince Philip.

Princess Anne, six, was also there to see her big brother's enthusiasm for games.

Although not yet a skilful sportsman, the young Prince seemed to be in the thick of each event.

Crowds watched through the railings as Charles tackled circular cricket and won a relay race with his team.

The Prince even suggested a gun carriage event he had seen at the Royal Tournament and threw himself into the obstacle course with all the gusto you would expect from a future leader of the Armed Forces.

Prior to Hill House, Charles had been educated at home by Catherine Peebles, his Scottish governess.

The heir apparent was expected to do well academically. Sir Winston Churchill said of the Prince on meeting him shortly before his fourth birthday: "He is young to think so much."

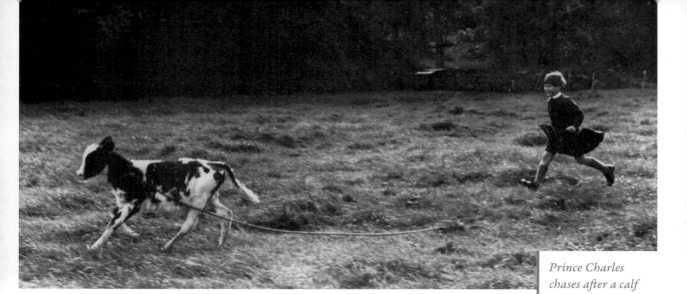

Prince Charles chases after a calf that broke free from him at the farm at Balmoral.

COWBOY OF THE CASTLE

SEPTEMBER 18, 1957

Och aye the moo.

Prince Charles gave chase to an Ayrshire calf that broke away from him during a visit to the dairy farm at Balmoral Castle.

Charles and his sister Princess Anne, both wearing kilts, walked with their mother and father to the estate's cattle sheds, where the young Prince fed cows through the fence.

Brother and sister then ran across a field to play with the calves. Anne, seven, collapsed in giggles as her brother attempted to lead a stubborn calf by a rope. It would not budge. Even their father, Prince Philip couldn't get the animal to move.

The Queen had passed on her love of animals, the countryside and her 50,000 acres in Scotland to her children.

Her Majesty had taken her family to her Aberdeenshire estate almost every year since becoming monarch. She founded the Balmoral pedigree herd of Highland Cattle in 1953.

She too spent many happy summers there as a child.

Balmoral has been one of the residences of the British Royal Family since 1852, when the estate and its original castle were bought by Prince Albert, Queen Victoria's husband.

FROM BALMORAL
TO BOARDING SCHOOL

SEPTEMBER 23, 1958

Prince Charles started boarding at Cheam School.

He was to use the same classrooms and dormitories as his father, Prince Philip, who also attended the Berkshire prep school.

Queen Elizabeth, Philip and their son, the Duke of Cornwall, travelled 500 miles from Balmoral to his new home by royal train.

They arrived at 6pm, by convertible Jaguar from Newbury Station, and were met by Cheam Headmaster Peter Beck.

The young Prince wore a royal blue school cap with the monogram "C", which he raised to Mr Beck as they shook hands. While the school tie was blue, Charles wore a black tie because the Royal Family was still in mourning for his great, great uncle, King Haaken of Norway.

The headmaster's wife led him and his parents into the hall. Many of the pupils had already arrived and watched through the windows.

Charles was reported as "taking a lively interest in his dinner" on his first evening.

A press conference was held in which Mr Beck appealed to the press to leave the school in peace despite the arrival of its new royal pupil.

The heir apparent was to share a dorm with nine other boys. The day started at 7.15am with a scramble for the bathroom.

Plain food was served to the 80 or 90 boarders in the dining room.

Cheam School was founded in 1645, making it the oldest private school in the country. Its main building is a former Georgian farmhouse set in 55 acres.

Charles at Cheam. He later told how Peter Beck caned him twice, but the Prince still invited his former headmaster to his 1981 wedding. Charles learned he would become Prince Of Wales while at Cheam.

PRESIDENT POPS IN FOR A PICNIC

AUGUST 29, 1959

President Eisenhower flew to the Highlands to receive a warm welcome from Britain's Queen and the future King.

"Ike" was the first American head of state to be honoured with an invite to Balmoral Castle, Scotland.

The Queen, pregnant with her third child, paced up and down at the castle gate, waiting for the President to arrive with Prince Philip, who had met him at the airport.

The two heads of state inspected the honour guard provided by the Royal Highland Fusiliers, then were driven by Daimler up the winding driveway to the Castle itself.

The party, which included Eisenhower's son John, was joined by Prince Charles, ten, and Princess Anne, eight, for a press photo shoot on the lawn.

The two young royals were captured smiling with the President and their mother, father and aunt, Princess Margaret. Both Charles and Anne wore kilts.

They clasped their hands behind their backs, just like their father, as they walked back into the castle, joking with the President.

Such was the informal nature of the overnight stay that the Queen acted as Ike's chauffeur on a tour of the estate. The party then enjoyed a picnic by Loch Muick.

The President asked the Queen for her recipe for drop scones, which she promised to forward.

Eisenhower travelled onwards to Chequers, the Prime Minister's country residence in Buckinghamshire, where he met Harold Macmillan.

Charles would go on to meet nine of the next 11 US Presidents, all except John F. Kennedy and Gerald Ford.

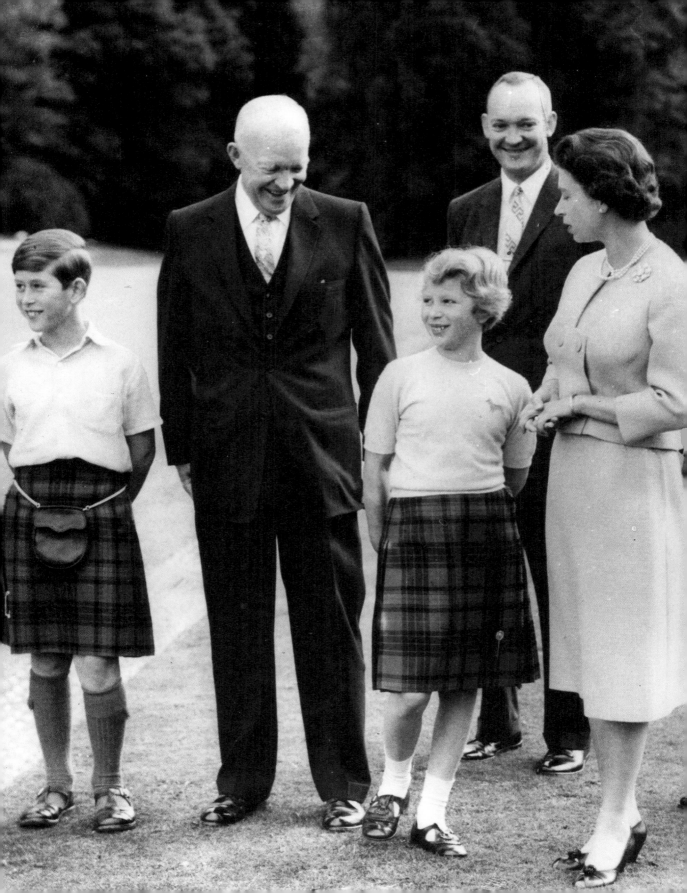

*Charles in his first and last
years at Gordonstoun which he
described as "like Colditz with
kilts" but he later looked back
more fondly at his time there.*

CHARLES, 14: I'LL HAVE A BRANDY PLEASE, BARMAN

JUNE 28, 1963

Buckingham Palace admitted 14-year-old Prince Charles was caught ordering a cherry brandy in a hotel in the Hebrides.

Officials had previously denied reports that the heir to the throne had been busted, but later apologised after being "misled" by the Prince's bodyguard.

The Prince sailed from his school, Gordonstoun, to Stornoway, on the Isle of Lewis, with four other pupils. They walked to the Crown Hotel for a meal.

But before the food arrived Charles slipped into the bar to avoid passersby looking through the restaurant window at him. He ordered a cherry brandy from the landlord, paying half a crown for the alcohol, which was illegal to buy at this age and certainly not allowed at Gordonstoun. A journalist happened to be sitting at the bar and overheard the exchange.

The Prince's bodyguard and friend Don Green, who had accompanied him on the trip, was fired over the incident.

Gordonstoun was chosen for Charles because his father believed his old tough and sporty school would do the shy Prince good.

The Queen Mother disagreed. She wrote to her daughter in 1961 recommending Eton College, just a mile from Windsor Castle. She warned: "He would be terribly cut off and lonely in the far north."

Gordonstoun was established in 1934 by German Kurt Hahn, a Jewish educationalist who fled the Nazis. His motto was 'Plus Est En Vous' – 'There Is More In You'.

Charles arrived at the 18-acre establishment in April 1962, aged 13. The school day started with a run every morning, followed by a warm shower – then a cold one.

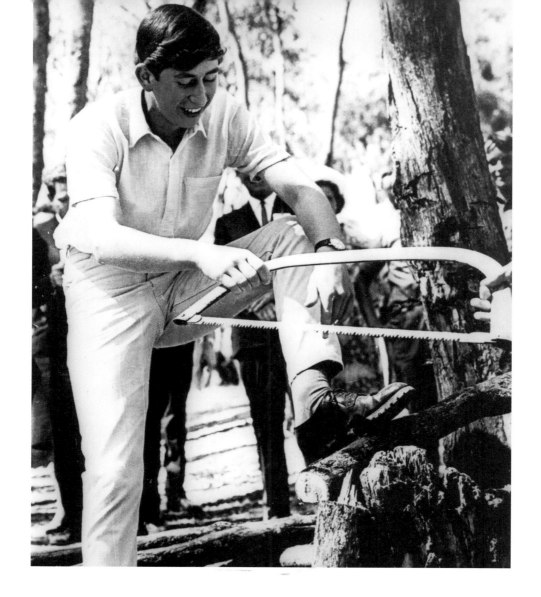

TREE-MENDOUS TIME AT TIMBERTOP IN OZ

FEBRUARY 16, 1966

The young man energetically sawing a log in the Australian bush could have been any other 17-year-old student.

In fact, it was Prince Charles who was

in the far reaches of the Commonwealth to attend the rugged outdoor school Timbertop, in the bush of Geelong, Victoria.

His parents felt the experience would take him away from the inevitable exclusivity of royal life and teach self-reliance.

Head teacher Mr T.J. Garnett told reporters: "I can't emphasise enough that, in accordance with his parents' wishes, the Prince will be treated like any other pupil.

"Boys and masters will address him as 'Charles'. He will be given no special favours."

The only concession for Charles was that he had his own dorm and stuck to his British A-Level curriculum of French, History and English. But that was because he was two years older than other pupils.

The grammar school was inspired by Charles's Scottish school, Gordonstoun and its founder, Kurt Hahn.

The emphasis was similarly on physical fitness but with regular hikes through the bush in blistering heat rather than the damper weather of Scotland.

For his two terms Charles was expected, like all pupils, to do all chores, including chopping wood. He also spent two weeks in Papua New Guinea on a school field trip.

Charles visited Sydney during his time in Oz.

At Bondi Beach he was met by an honour guard of male lifeguards and watched a demonstration of rescue and resuscitation.

While Aussies surfed the waves in swimsuits, the Prince hit the beach in a suit and tie.

He got the last laugh; the weather was freezing cold.

Prince Charles meeting lifeguards at Bondi Beach.

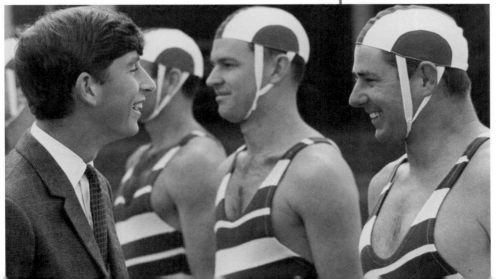

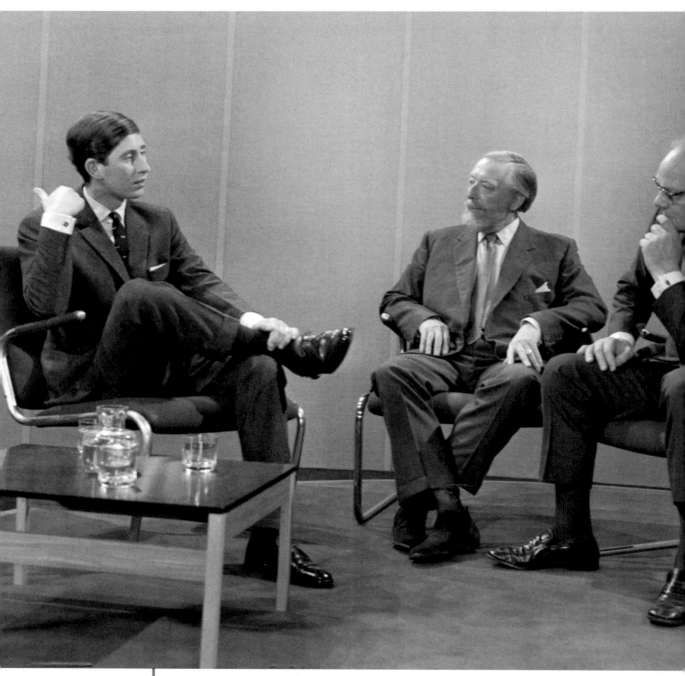

Charles interviewed by Brian Connell and
Cliff Michelmore to mark his Investiture.

'SHY, LONELY... BUT I'LL CONQUER IT'

JUNE 26, 1969

Prince Charles admitted life as heir to the throne could be "lonely" in a bombshell TV interview.

The fresh-faced Cambridge student told presenters Cliff Michelmore and Brian Connell: "I haven't made a lot of friends or been to a lot of parties. I suppose compared with other people's lives it is more lonely.

"I am fairly shy, but one has to conquer this. I don't make friends all that easily. The position one's in might be a barrier."

The BBC and HTV interview marked Charles's Investiture as Prince of Wales.

The royal recalled the "bewildering" moment at the 1958 British Empire and Commonwealth Games in Cardiff when the Queen announced that he would assume the title Prince of Wales.

Charles said: "I remember sitting in the headmaster's study at Cheam. We were all watching television, there were several other boys there. I remember being acutely embarrassed when it was announced. For a little boy of nine it was bewildering.

"The others all turned and looked at me in amazement."

The Prince spoke fondly of his mother. He said: "I tend to think of her as a marvellous person and a wonderful mother. I think of my family as very special people. The Queen has a marvellous sense of humour and is terribly sensible and wise."

Michelmore raised Prince Philip's reputation for rudeness, asking: "He tells people 'sit down and shut up'... has he ever said that to you?"

Charles laughed: "Yes, all the time, it's good for one. He has had a strong influence on me."

He added: "My father has been a great help; he lets one get on with it and gives you the opportunity to get on with it. He has been a moderating influence and an influence of great wisdom."

Asked about his future, Charles said: "Time in the services is a very good idea. It gives one a useful experience, a sense of discipline and responsibility. A sense of responsibility is the most important thing.

"'Ich Dien', 'I serve', is a marvellous motto to have. That is the basis of one's job."

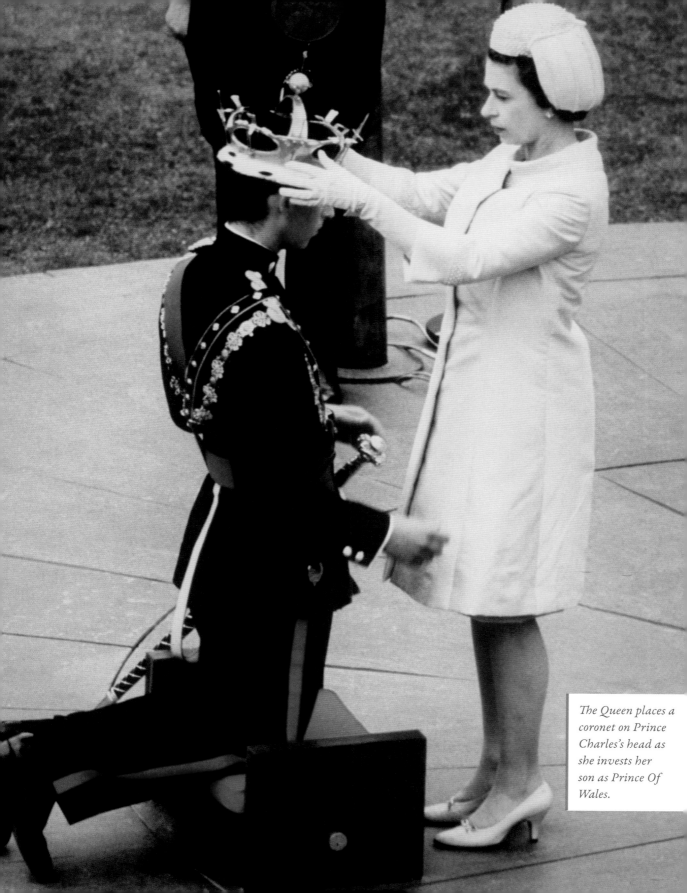

The Queen places a coronet on Prince Charles's head as she invests her son as Prince Of Wales.

INVESTITURE OF PRINCE OF WALES

JULY 1, 1969

This was the moment the Queen proudly invested her "most dear son" as Prince of Wales.

Her Majesty gently fastened a sword around Prince Charles's waist and a gold ring on his finger. Each item represented his symbolic power in Wales, his unity with its people and his duty to defend his country.

With motherly pride, she buttoned her son's ermine cape, straightened it on his shoulders, then solemnly placed a coronet on Charles's head, as he kneeled before her in the blue uniform of the Royal Regiment of Wales.

After the Prince pledged his loyalty to the Queen, she placed a kiss on his left cheek.

The pageantry on display at Caernarvon Castle echoed the medieval chivalry of its founder Edward I but was beamed around the world by 20th century television cameras perched on every available turret.

A dozen processions entered the castle through the Eagle Tower. A fanfare from the trumpeters of the Household Cavalry announced each arrival.

Inside the castle a choir selected from all over Wales sang.

As the Queen and the Duke of Edinburgh were conducted to their seats on a central stage, the surrounding audience sang the soaring Welsh national anthem, Ancient Land of My Fathers.

Charles addressed his people in Welsh: "It is, indeed, my firm intention to associate myself in word and deed with as much of the life of the Principality as possible – and what a principality!"

Of the 4,000 guests, 3,000 were from Wales. They reacted warmly to the Prince tackling the Celtic language.

He had spent two months studying and said in a recent TV interview: "The double Ls were fairly difficult to learn. I went to Llanelli recently. The mayor asked if I could say 'Llanelli'. I said 'Llanelli'. He wiped the saliva out of his eye and said 'Well done'."

BLAZING A TRAIL FOR THE ENVIRONMENT

FEBRUARY 19, 1970

In a passionate speech about the environment, Prince Charles warned that the future of the planet rests with all of us.

The 21-year-old royal told the Countryside in 1970 Conference: "We are faced at this moment with the horrifying effects of pollution in all its cancerous forms.

"There is the growing menace of oil pollution at sea, which almost destroys beaches and certainly destroys tens of thousands of seabirds.

"There is chemical pollution discharged into rivers from factories and chemical plants, which clogs up the rivers with toxic substances and adds to the filth in the seas. There is air pollution from smoke and fumes discharged by factories and from gases pumped out by endless cars and aeroplanes."

He went on to tell the Cardiff audience: "When you think that each person produces roughly 2lb of rubbish per day and there are 55 million of us on this island using non-returnable bottles and indestructible plastic containers, it is not difficult to imagine the mountains of refuse that we shall have to deal with somehow."

The Prince was one of the first major public figures to address ecological concerns and risked criticism of the Royal Family by becoming involved in public policy.

Charles's interest in ecology was thought to come from his time on the Queen's estates as well as his studies in archaeology and anthropology in his first year at Cambridge University.

His father, Prince Philip, the Duke of Edinburgh, was a keen ecologist. The Duke's first book Birds from Britannia was published in 1962.

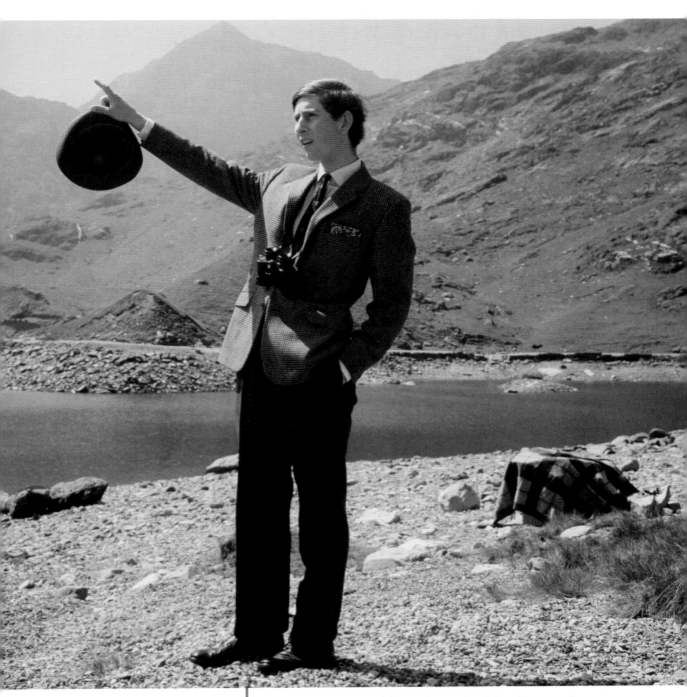

Charles explored beautiful Snowdonia after delivering a speech about protecting the countryside which was way ahead of its time.

CHARLES FORGETS HIS FLIPPIN' LINES

FEBRUARY 23, 1970

Prince Charles donned flippers to play a weatherman in a Cambridge University student comedy show.

Charles got stuck into his part in Quiet Flows the Don with gusto, but forgot his lines.

He revealed his mistake halfway through his monologue playing a weatherman, saying: "What the hell comes next? This does not happen at the BBC."

That line got the biggest laugh of the evening.

The show was put on by the Dryden Society of Trinity College, Cambridge, of which the student Prince was a member.

Charles appeared on stage wearing a Mac, diving fins, a gas mask and carrying a tin of juice.

His forecast was wordy but not hilarious.

"By morning promiscuity will be widespread, but it will lift and may give way to some hill snog.

"Fist and bog patches... and needless to say virility will at first be poor... a manic depression over Ireland. An obsession over Sweden will be relieved by a warm front to be followed shortly by a cold back."

Charles was a keen thespian. He played Macbeth at Gordonstoun, aged 17, to rave reviews.

In his interview with Cliff Michelmore before his Investiture, the Prince said he would have considered becoming an actor.

He said: "I've often thought about that. It's great fun, I love doing it. Whether I could do it professionally is another matter. It gives me great pleasure.

"Having an interest like that keeps one sane."

He revealed the Royal Family loved charades. "It's the greatest possible fun. I love it."

Charles in a comedy performance at Cambridge University.

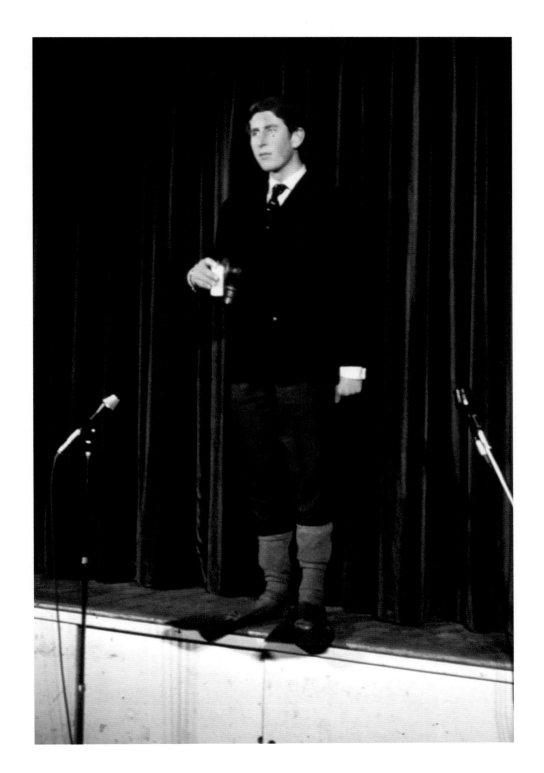

Lucia Santa Cruz was doubly significant in Charles's life. She went on to introduce Charles to the woman who lived in the flat below her in London – his future wife, Camilla Shand.

THEATRE DATE WITH CAMBRIDGE FRIEND

APRIL 16, 1970

Get a vroom! Prince Charles was snapped with the woman thought to be his first girlfriend, Lucia Santa Cruz, leaving the Fortune Theatre, London.

The couple had attended a performance of David Storey's play The Contractor.

The glamorous 5ft 4in South American, five years older than the Prince of Wales, was research assistant to Lord "Rab" Butler, Master of Trinity College, Cambridge, where Charles was studying history.

He was the first member of the Royal Family to attend university.

Charles was described as awkward and shy by guests who observed him at parties, often standing on his own. But insiders said his relationship with Miss Santa Cruz helped build his confidence.

Lord Butler introduced the two at a dinner party in Spring 1969, Charles's second year at the university, and they hit it off straight away after discovering a shared interest in art and history.

Lucia, the daughter of the Chilean Ambassador to the UK, was ferociously intelligent as well as beautiful. She was fluent in five languages, with degrees from Kings College, London and Oxford University and had just published a book, Three Essays on Chilean Women.

She was also Catholic, which would prevent a marriage between the two.

In his BBC interview with Cliff Michelmore, Charles said: "When you marry in my position you are going to marry someone who will become Queen. And you've got to choose somebody very carefully who can fulfil this particular role. It has got to be someone pretty special.

"The one advantage of marrying a Princess is that they do know what happens. The only trouble is I'd like to marry somebody English, or British."

37

ROYAL KIDS IN AMERICA

JULY 18, 1970

Princess Anne and Prince Charles received a warm welcome from Americans as they flew from Canada into the Washington sunshine.

The only pity was that so few Americans would see the "Royal Kids" – as the U.S. newspapers called them.

It was strictly a private visit. The President's daughter Tricia Nixon, sister Julie and Julie's husband, David Eisenhower, claimed the royal visitors for themselves.

There had been widespread speculation of a romance between Charles and Tricia Nixon.

Lovely, blonde, Tricia, who had never met Charles, had long been rumoured to have a crush on him.

Mrs Nixon's staff had a hectic time telling journalists: "There is no romantic link whatsoever."

At a press briefing in the White House, Connie Stuart, Mrs Nixon's ebullient staff director, acknowledged that God may be more powerful in these things than the President.

Charles and President Nixon spent an hour and 20 minutes alone in uninterrupted conversation at the White House.

"The Prince obviously made a very good impression on the President," said the deputy White House press secretary, Gerald Warren, remarking that the meeting had run overtime and had lasted longer than those Mr Nixon usually held with foreign statesmen.

Mr. Warren said the Prince and the President had discussed, among other things, world affairs – with emphasis on British-American relations – the environment, attitudes among youths and world population problems.

This was all a little different from the last time a Prince of Wales was in the country and was asked if he would marry an American girl if he fell in love with her.

The then future King Edward VIII said he would. And he did.

The President's daughter and Queen's son attend a Washington Senators baseball game at RFK Stadium, Washington DC. The Prince would later refer to the trip as "the time they were trying to marry me off to Tricia Nixon."

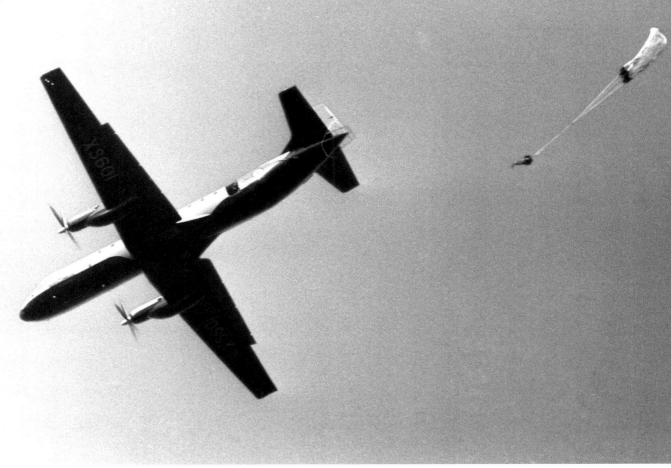

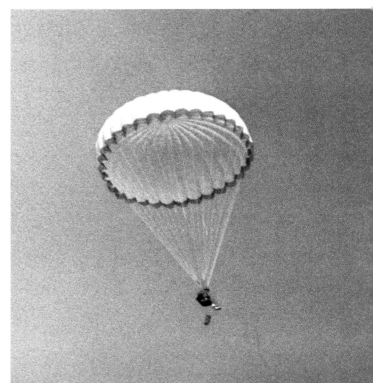

Charles during his parachute jump at Studland Bay, Dorset.

THE PARACHUTING PRINCE DROPS IN

JULY 29, 1971

The action man plummeting to earth from 1,200 feet – watched by thousands of holidaymakers – was none other than Prince Charles.

Not only did he have the courage to jump, he had the calmness to untangle his feet from the parachute's rigging lines in mid-air.

His death-defying leap into the sea nearly had to be called off when hundreds of boats carrying sightseers clustered around the landing-zone off Studland Bay, Dorset.

The tourists dispersed when it was pointed out that they were in the way.

At 6.02pm the 22-year-old heir to the throne jumped.

A parachute opened out automatically as he left the aircraft, and once he'd disentangled himself, he swung gently to Earth.

Seconds later he splashed into the calm water, protected by his special rubber wet suit and lifejacket.

Teams of Royal Marines in rescue boats sped to pick him up.

The Prince changed into dry clothes as soon as he boarded the rescue launch returning him to the Royal Marine amphibious training base at Poole.

Charles made the first royal parachute drop as part of his course at RAF College, Cranwell, where his codename was "Golden Eagle".

He was presented with his pilot's "wings" on August 20 – three weeks before joining the Navy on the advice of his father and great uncle, Lord Mountbatten.

The drop was not necessary to get his "wings". Charles had been taught to fly while at Cambridge University, but he insisted.

He said afterwards that he felt "exhilarated and happy beyond belief."

VISITING THE DUKE AND DUCHESS OF WINDSOR

MAY 18, 1972

This historic family snap is a rather special picture for the Windsor album.

It shows the Queen, Prince Philip and Prince Charles calling on the Duchess of Windsor for tea.

The photograph marks only the second time the Queen officially met her aunt, the woman for whom her uncle, then Edward VIII, gave up England's throne.

Once the Windsors' romance was the world's greatest love story. Edward VIII abdicated to be with Mrs Wallis Simpson, an American divorcee, in 1936. She was considered an unsuitable match for him as head of the Church of England.

He was the only British sovereign ever to give up the Crown.

Since giving way to his brother, the Queen's father, George VI, the Duke had lived in exile with his soulmate. Now that romance looked like having a storybook ending with the family reconciled.

The gathering at the 77-year-old Duke's Paris home was an emotional occasion for all involved.

Edward was refused permission to leave his room but was said to be in good spirits. He had been suffering from fatigue with a hernia condition.

Charles had been to visit his great uncle on an unannounced private visit in October 1970.

He made the trip to Paris with Christopher Soames, the British Ambassador to France, and his son Nicholas, a close friend of the young Prince.

Although the Duke did not attend Charles's Investiture, he watched it on TV and described his great nephew as "intelligent and perceptive."

The Duke of Windsor died on May 28, 1972, and the Duchess in 1986.
They are buried side-by-side at Frogmore in the grounds of Windsor Castle.

JUST THE GIRL FOR YOU: CHARLES MEETS CAMILLA

SUMMER, 1972

Charles's Cambridge friend Lucia Santa Cruz introduced the Prince to "just the girl for him".

Lucia invited him for a drink at her flat near Victoria Bus Station in London and asked her downstairs neighbour, Camilla Shand, to join them.

Lucia jokingly warned the couple: "Now you two, watch your genes."

Charles's great-grandfather Edward VII had a scandalous affair with Alice Keppel, Camilla's great-grandmother.

But the Prince was immediately smitten by the 26-year-old socialite's goofy sense of humour, lack of pretence and great warmth. She was affectionate and unassuming.

Just one issue – Camilla had been the on-off girlfriend of the Prince's polo friend Andrew Parker Bowles, who had also dated Princess Anne.

The handsome army officer was notoriously unfaithful. Camilla took the chance when Andrew was serving abroad to spend time with the Prince.

They were frequently together dancing in Annabel's nightclub in London, attending polo matches and staying at Lord Mountbatten's estate, Broadlands, in Hampshire, where they were left to spend time alone.

Great Uncle Dickie had counselled Charles to enjoy his bachelor life before choosing a wife.

Despite the strength of feeling between the love-struck pair, the relationship was destined to end quickly. Navy officer Charles set sail for the Caribbean in December 1972 for eight months – just as Parker Bowles returned home.

Charles and Camilla Shand at a polo match in Windsor in 1972.

DEAR CHARLES, WE ARE GETTING MARRIED

SUMMER, 1973

HMS Minerva pulled into Chatham dockyard to bring its crew home after an eight-month tour of the Caribbean.

The ship's Acting Sub Lieutenant – Prince Charles – was delighted to be back. He wrote in his diary: "Drake's own country appeared blue and hazy under dark scudding clouds and shafts of August sunshine."

Life had changed dramatically for Charles since Minerva set sail in December.

His friend Camilla Shand announced her engagement to Andrew Parker Bowles on March 15 in *The Times*. The couple married at the Wellington Barracks, London, on July 4 with the Queen as guest of honour.

Charles noted sadly in his diary: "I suppose the feeling of emptiness will pass eventually."

In early May Charles received a letter from his father informing him Princess Anne – confidante and friend as well as his sister – was to marry army captain Mark Phillips.

Charles's naval and royal duties kept him busy. He travelled to Montserrat, Jamaica, Colombia, Venezuela, St Kitts, the Cayman Islands, Mustique, the Bahamas and Barbados. He attended at least forty cocktail parties.

He also slipped away for a holiday on the island of Eleuthera with his great uncle Lord Mountbatten's family. Charles spent time with Mountbatten's granddaughter Amanda Knatchbull.

He said of his holiday: "I have never experienced life more closely resembling paradise on earth."

Acting Sub Lieutenant Charles checking a weather report on HMS Minerva as the ship leaves Plymouth.

CHOPPER CHARLIE

SEPTEMBER 9, 1974

Charles aboard a helicopter.

Prince Charles joined the rotor-y club by starting a three-month course in helicopter flying.

After 20 minutes of instruction, the Prince and his teacher Lt-Cdr Alan MacGregor, took off.

Meanwhile all aircraft in the area had been told to "keep well clear."

A special 12-strong Red Dragon squad had been formed to bring Charles up to operational standards.

RIGHT ROYAL OUTING FOR GOONS

NOVEMBER 11, 1974

Goons fan Prince Charles was treated to some special ying tong poetry when he met three of the famous foursome.

Harry Secombe sent the rhyme as an apology when he came down with a sore throat which stopped him attending a reunion of BBC radio comedians The Goons.

His three comedy colleagues Peter Sellers, Spike Milligan and Michael Bentine had to manage without him at the event at

the Dorchester Hotel, London. Charles tucked into a salmon mousse as Peter Sellers read the lines:

"Oh spare a thought for poor old Ned,
Lying sick upon his bed,
Wishing he were there tonight,
Instead of being struck with blight,
To Peter I send fondest wishes,
And wonder who his latest dish is.
I wish I had his energy
They're putting something in my tea."

As the guests laughed, Sellers read out the last lines of Secombe's ode which were directed at Prince Charles.

"And lastly for our royal guest,
A cheer from my wheezy chest,
Forgive my tendency to grovel,
But he's just reviewed my latest novel."

Before the dinner, The Goons were beckoned to leave the bar to meet the Prince, but Milligan joked: "We're all too old for that, we cannot make it."

As Charles shook the hand of one guest in an evening gown, Spike shouted: "Unhand that lady, Sir!"

Charles was known to adore the radio comics, who last performed in 1972. Schoolmates in Australia remembered his excellent impressions of their sketches.

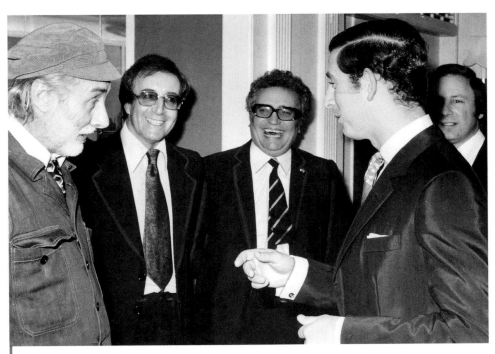

Charles meets Spike Milligan, Peter Sellers and Michael Bentine. He and Camilla nicknamed each other Gladys and Fred after two of their characters.

FOR ONE'S NEXT TRICK

OCTOBER 28, 1975

Quick-fingered Prince Charles secretly won a place in the elite Magic Circle of magicians.

His skills as an amateur conjuror stunned a panel of professional illusionists.

The Prince of Wales did an amazing routine with cups and balls and a trick in which shredded paper was made whole.

He had to perform the illusions in front of the public to gain membership of the Magic Circle at the organisation's headquarters in central London.

Cups and Balls is a classic trick where balls mysteriously appear and vanish beneath three cups, often with unexpected objects appearing at the end.

The Prince practised the stunts at home where his mother the Queen was also a big magic fan. She used to impress palace staff with her performances while still a teenage Princess.

Charles's uncle, Lord Mountbatten, was also an enthusiastic amateur.

They both performed regularly at Christmas parties and private celebrations at the palace.

Charles took it much more seriously, as one would expect of a man with such an inquisitive mind.

Charles is a lifelong fan of magic. The Prince's Trust later supported superstar magician Dynamo at the start of his career.

50

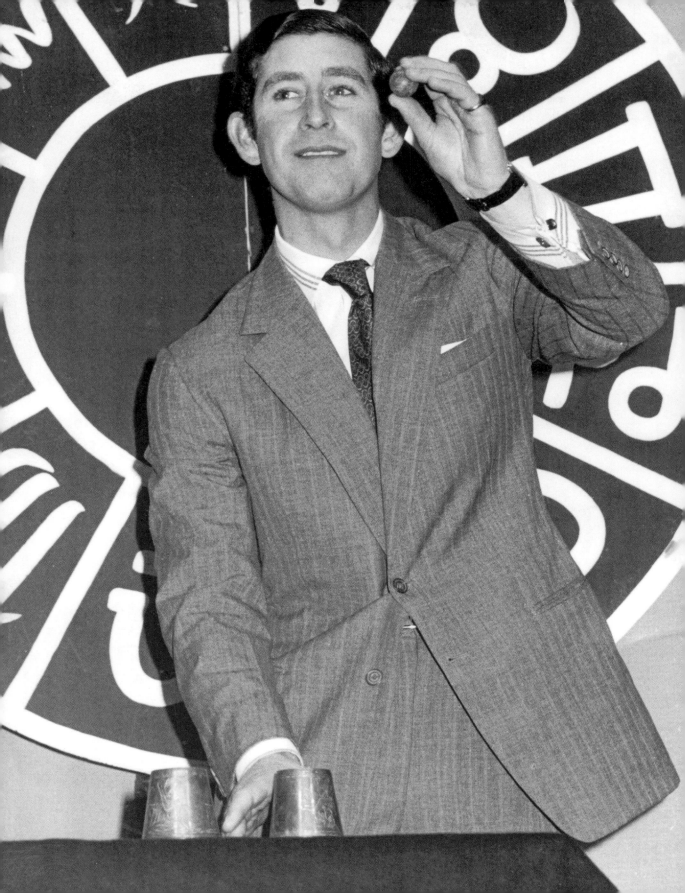

AT LAST, A THRONE... NAVY SENDS YOU THEIR LAV, CHARLES

DECEMBER, 1976

Prince Charles looked flush as he was given a warm farewell by the crew of his ship HMS Bronington.

His fellow sailors hung a toilet seat around his neck and rolled the laughing Prince down the dock in a wheelchair as they said goodbye to their royal commander on his last day in the Royal Navy.

Charles was put in charge of the minesweeper in February 1976 then patrolled the North Sea, Irish Sea and North Atlantic. On board he had no protection officers and rubbed shoulders with sailors from all backgrounds.

Prince Philip, Prince Andrew and Her Majesty the Queen had visited him on board.

Like his father before him, Charles gained valuable experience in the Navy, from his six-week course at the Royal Naval College Dartmouth in 1971 to serving on guided-missile destroyer HMS Norfolk and the frigates HMS Minerva and HMS Jupiter between 1971 and 1974.

His only drama onboard was an anchor getting tangled up in an underwater telephone cable. Personally, he had grown in confidence.

His final report said he had attained an "excellent level of professional competence". Commander Elliott, the senior officer of the squadron, singled out the heir to the throne's empathy for his crew. "Prince Charles has shown a deep understanding for his sailors and their families and their problems and as a result the morale of the ship has been of an extremely high order."

With his severance pay of £7,400, Charles was keen to help improve the lives he had learned more about on board. He funded 21 projects around the country to encourage young people into employment.

These initiatives were the founding projects of The Prince's Trust.

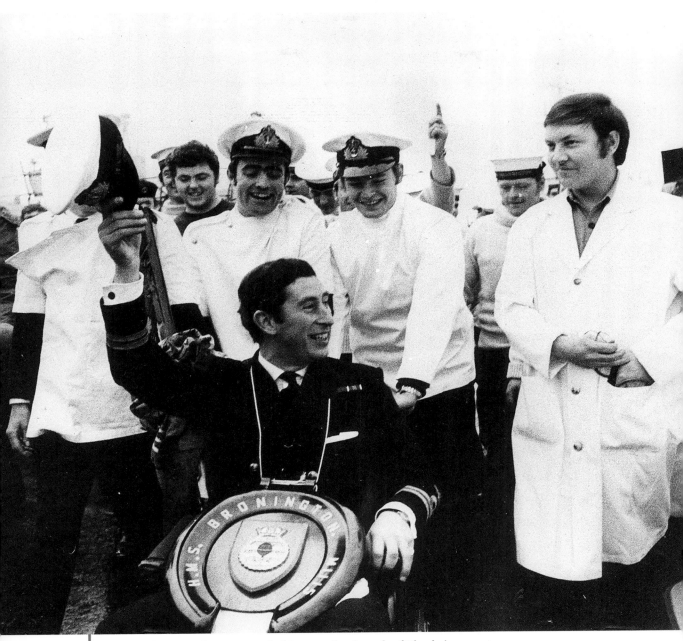

Commanding one of Her Majesty's ships was the pinnacle of Charles's military career and the spirt of solidarity onboard sparked the idea for The Prince's Trust.

PANIC IN THE HEIR

MARCH 24, 1977

A plane carrying Prince Charles narrowly missed smashing into a guard of honour marching across an airstrip to greet him.

At the last second the pilot, Squadron Leader Derek Lovett, spotted the soldiers, slammed on full throttle, and soared clear with feet to spare.

He landed the twin-engined Andover safely a few minutes later on the unmade runway at Navrongo close to the Sahara Desert.

Only minutes before, the Prince himself had been at the controls of the plane – call sign Unicorn – which was part of the Queen's Flight.

Squadron Leader Lovett had taken command because of the difficulties of landing at the remote airstrip.

After the landing, the Squadron Leader said: "It was not really as bad as it looked.

"I spotted these men far too close for comfort and immediately decided to overshoot."

Major George Ayietey, a Ghanaian Air Force pilot, said: "It was jolly quick thinking by the pilot. The plane was only 25 feet from touch-down when he took off again."

The 142 soldiers and five officers of the 6th Battalion of the Ghana Infantry were being moved to take up their positions for the Prince's arrival.

When Charles inspected the battalion, no mention was made of the incident.

The day before, the Ashanti Tribe in Kumasi held a Durbar (royal welcome) in his honour. The Prince attended in full naval dress uniform.

Charles's friendship with South African writer Laurens van der Post piqued his interest in the continent. A planned trip with his guru was turned down by the Foreign Office in favour of a more formal visit to Ghana.

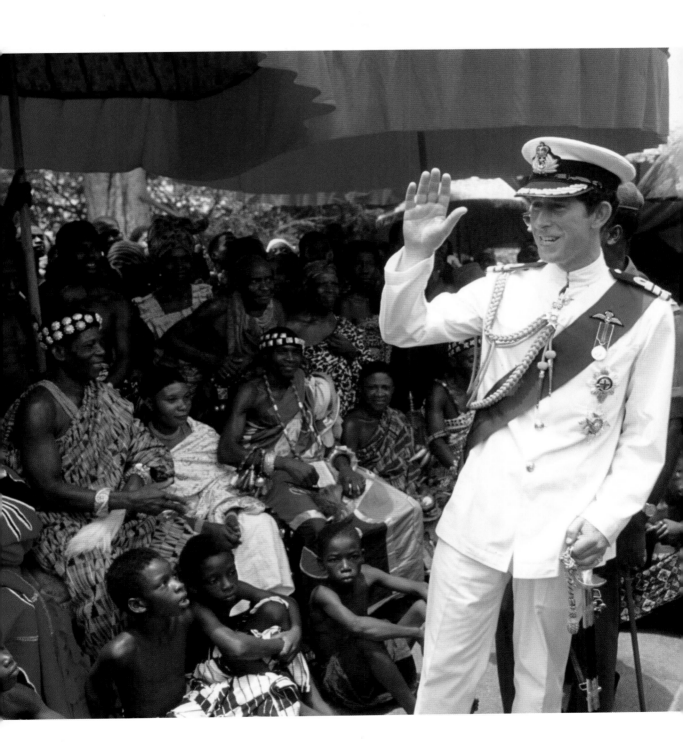

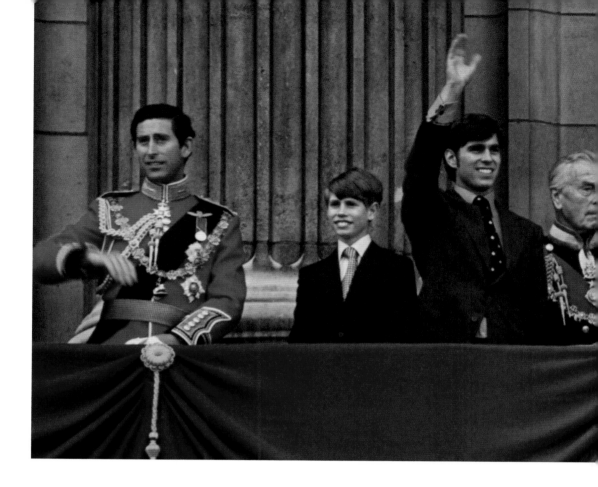

JUBILATION NATION

JUNE 7, 1977

Britain impressed the world with its mix of tradition and fun as Queen Elizabeth II marked 25 years on the throne with her Silver Jubilee.

The highlight of a weekend of street parties and flag-waving was the carriage ride from Buckingham Palace to St Paul's Cathedral which enabled people who had camped overnight to steal

a glimpse of their monarch. She was accompanied by Prince Philip.

Behind them, on horseback, rode their handsome son, Prince Charles, in the uniform of the Welsh Guards. His bearskin proved wearable in the June sunshine.

Over a million people lined the streets to catch sight of the ornate gold state

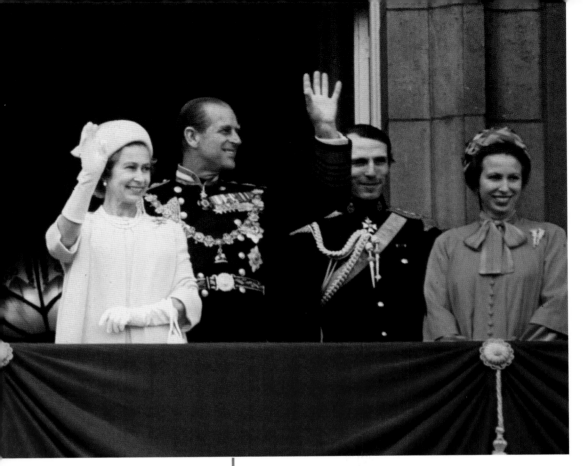

The Queen was just 51 at her Silver Jubilee, bringing into sharp focus Charles's need to find purpose before inheriting the Crown.

coach first built for George III in 1762.

The procession, led by the Household Cavalry, took the Royal Family's carriages along the Mall, through Trafalgar Square, through the City of London and to St Paul's Cathedral for a service.

Later, Princes Charles, Edward and Andrew, Lord Mountbatten, the Queen, Prince Philip, Major Tim Lawrence and Princess Anne appeared on the Buckingham Palace balcony.

The Queen looked stylish in a pink jacket, matching hat, pearls and white gloves.

A chain of beacons were lit across the nation the previous evening. The Queen set light to the first one at Windsor. In the reign of Elizabeth I, a similar chain warned of the coming of the Spanish Armada.

Charles was in charge of the Silver Jubilee Trust, to raise money for disadvantaged people, through the year of celebration.

CROWN PRINCE

JUNE 9, 1977

Prince Charles's big secret was out... a patch in his thatch.

His bald spot was the size of an egg – right on top of his royal crown.

Like Dad, the Prince was going thin on top. And he was only 28.

All was revealed after a game of polo at Cirencester, Gloucestershire.

Charles took off his black polo helmet in the car park.

As he sped away in his Aston Martin open sports car, his bald patch was in full view.

No one had noticed the patch before... thanks to a right royal cover-up.

Charles normally took care to brush his dark hair in a way that hid any loss.

Prince Charles later asked photographer Arthur Edwards how many people had seen his picture of his bald patch. "Just three million readers," Arthur replied.

Prince Charles and Lady Sarah Spencer on holiday. She was later to introduce him to her sister, Diana

A HOLIDAY WITH LADY SPENCER

FEBRUARY 18, 1978

Lady Sarah Spencer ruled out any chance of becoming the next Queen of England.

Against Royal protocol, she spoke after returning from a ski trip with Prince Charles.

She said: "He is fabulous as a person but I am not in love with him.

"He is a romantic who falls in love easily. But I can assure you that if there were to be any engagement between Prince Charles and myself, it would have happened by now."

Lady Sarah, a 23-year-old redhead, spent ten days skiing in Klosters, Switzerland, with Charles.

She said: "I am a whirlwind sort of lady as opposed to a person who goes in for a long, slow, developing courtship. Of course, the Prince and I are great friends.

"Our relationship is totally platonic. I do not believe that Prince Charles wants to marry yet. He still has not met the person he wants to marry.

"I think of him as the big brother I never had."

She added: "I wouldn't marry anyone I didn't love whether it was the dustman or the King of England."

PRINCE AND THE NUDE

OCTOBER 30, 1978

Prince Charles showed his sense of humour after taking a long look at the naked beauty stripping off for a swim.

He turned to *Sun* photographer Arthur Edwards and said: "You should put her on Page 3."

The young woman who caught the Prince's eye was the subject of a painting in a Yugoslavian art gallery.

The picture by Jovan Bilic showed the beautiful bather getting ready to plunge into a cool mountain stream.

Charles saw other nude paintings when he visited the gallery at Novi Sad at the end of his royal tour but his attention lingered on the naked bather.

Prince Charles takes a look at Jovan Bilic's painting.

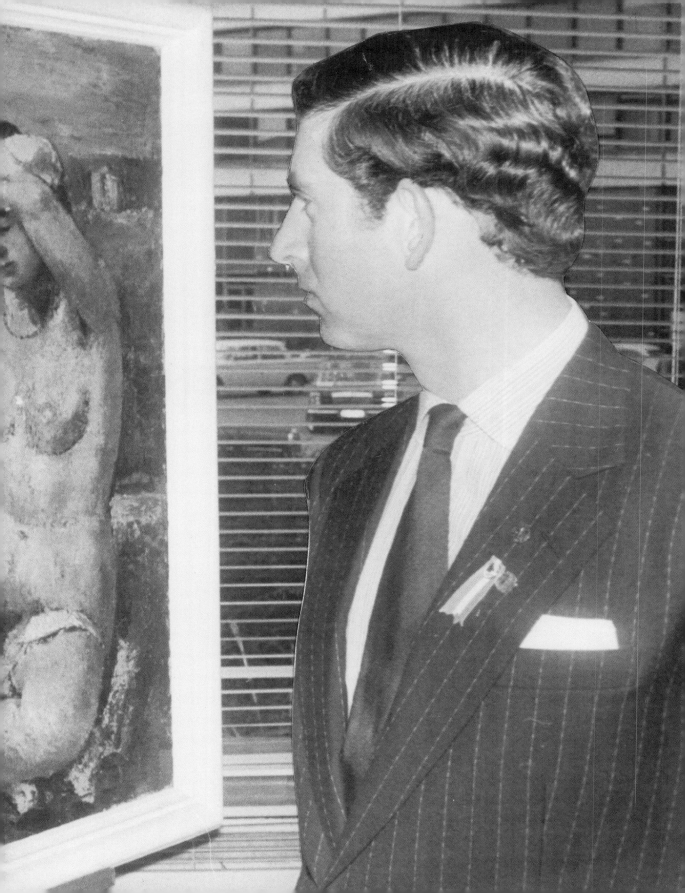

LORD MOUNTBATTEN ASSASSINATED

AUGUST 27, 1979

The water was calm off the Irish coast as a small fishing boat carrying Lord 'Dickie' Mountbatten and his family made its way out to sea.

Seconds later, a deafening explosion and piercing screams rang out across the water as a 50lb remote-controlled bomb – planted the night before by the IRA – was detonated.

It ripped the boat apart and killed Lord Louis Mountbatten, 79; his 14-year-old grandson, Nicholas; elderly Dowager Lady Doreen Bradbourne; and 15-year-old boat boy Paul Maxwell.

The only survivors onboard were Nicholas's twin brother Tim, and their parents John and Patricia.

To add to the horror, 18 British soldiers were killed just hours later in two bomb explosions near the Irish border – the deadliest day for the British Army during the Troubles in Northern Ireland.

Mountbatten had been an incredibly influential figure. He was last Governor General of India and Head of the Armed Forces. He was the brother of

Prince Philip's mother, Princess Alice of Battenberg, and the Queen's second cousin once removed. Charles looked to his great uncle for advice and Lord Mountbatten coached him on his career and his love life.

The Prince was in Iceland when he heard the news. He wrote in his diary: "I have lost someone infinitely special in my life; someone who showed enormous affection, who told me unpleasant things I didn't particularly want to hear, who gave praise where it was due as well as criticism, someone to whom I knew I could confide anything and from whom I would receive the wisest of counsel and advice. In some extraordinary way he combined grandfather, father, brother, and friend."

Sinn Fein finally apologised for Mountbatten's death 40 years later.

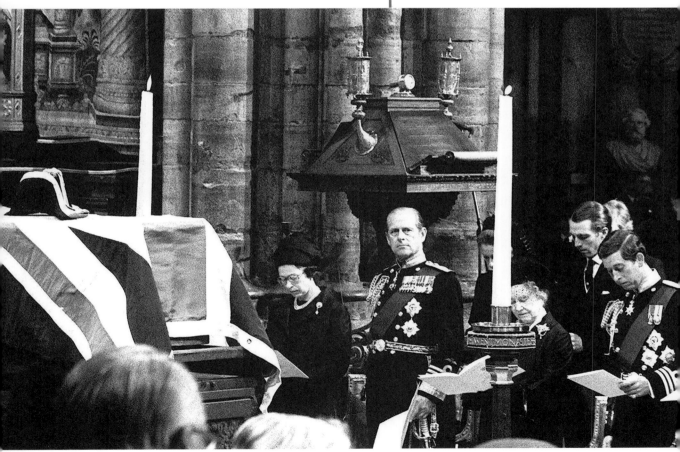

PRINCE HAS A NOSE FOR NEWS

JANUARY 24, 1980

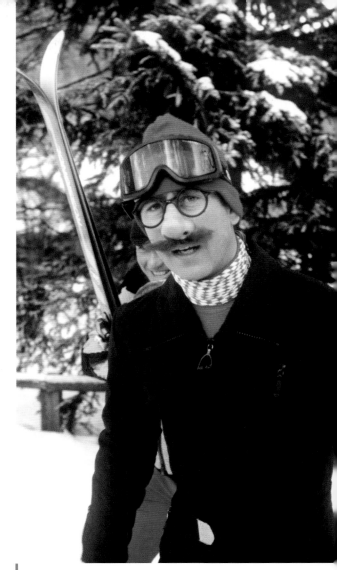

Introducing old Uncle Harry... alias Prince Charles.

Prince Charles tried to sneak past the press... in a disguise that was bound to hit the headlines.

He appeared outside his Swiss holiday chalet wearing a false moustache, specs and a funny nose and said in his best Goon Show voice: "Who do you think I am – Prince Charles or something?"

The pantomime performance was part of the cat-and-mouse game that the Prince had been playing with the press since arriving at the ski resort of Klosters.

He rarely managed to give reporters and photographers the slip. But just for a moment his hide-and-seek antics almost worked.

Just after breakfast, one of his holiday companions, Patti Palmer-Tomkinson, came out of the chalet and announced: "I'm sorry to disappoint you but HRH won't be skiing with us this morning.

"He's had an accident and is staying at home – but my old Uncle Harry will be coming with us instead."

Then out stepped Uncle Harry – alias the Prince in disguise.

After clowning with photographers for a moment he said: "I think I've earned a good day's skiing now."

And off he went.

A £1M COUNTRY HOME: HIGHGROVE

JULY 29, 1980

Prince Charles bought a new country home – for more than £1 million.

It was a Cotswold mansion called Highgrove, set in 347 acres of farmland – and just six miles from Princess Anne's home at Gatcombe Park.

The news came less than three weeks after Charles said he was quitting Chevening House, his 115-room mansion near Sevenoaks, Kent.

The Prince wanted a base in which to spend more time in the West Country and take a closer interest in the management of his Duchy of Cornwall, the private estate given to the heir to the throne.

Highgrove, in the village of Doughton, near Tetbury, Gloucestershire, was owned by Tory MP Maurice MacMillan.

It had four reception rooms, nine bedrooms, eight bathrooms and five stable blocks.

Buckingham Palace said the Prince would use the mansion as his private residence.

It made the ideal retreat for Charles, the country squire.

He was just a gallop away from Badminton House where he regularly hunted with the Duke of Beaufort.

For the world's most eligible bachelor, the quiet Cotswolds countryside was a beautiful landscape for discreet rendezvous with girlfriends.

The two local pubs were good for a pint – they were called the Prince of Wales and the Royal Oak.

65

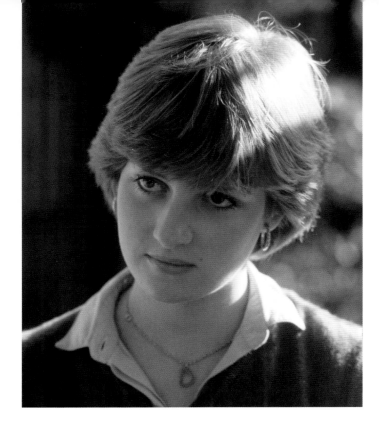

The shy nursery assistant was destined to become the most famous woman in the world.

CHARLIE'S GIRL

SEPTEMBER 17, 1980

The bubbly blonde teenager tipped as the next Queen of England stepped regally into the limelight for the first time.

Prince Charles's new girlfriend, vivacious 19-year-old Lady Diana Spencer, posed for photographers outside the kindergarten where she taught.

But she refused to speak about her romance with the Prince.

And that silence improved her chances of making the marriage of the century.

For the youngest daughter of the Earl Spencer was the first serious girlfriend of the Prince who had kept mum.

Strolling through the grounds of the Young England Kindergarten attached to St Saviour's Church in London's Pimlico, Lady Diana said: "You know I cannot say anything about the Prince of my feelings for him.

"I am saying that off my own bat. No one has told me to stay quiet."

It was years later before photographers recognised the significance of Camilla supporting Diana on this day.

HEDGING HIS BETS

OCTOBER 24, 1980

It's not every jockey that gets his current and ex-girlfriend cheering him on in a race.

But that's what happened when Prince Charles competed in the £1,200 Clun Amateur Riders' Handicap Chase at Ludlow.

The future King was riding his own horse Allibar which came home a decent second out of a field of twelve runners.

There to watch was Lady Diana Spencer and Charles's long-time friend Mrs Camilla Parker Bowles.

An onlooker said: "Diana jumped up and down and cheered as Charles raced. She was shy but so excited, she looked beautiful in a green coat and knee-length boots and laughed with her friend Camilla."

More excited were the photographers who realised this was the first time Charles and Diana had officially been seen in public together.

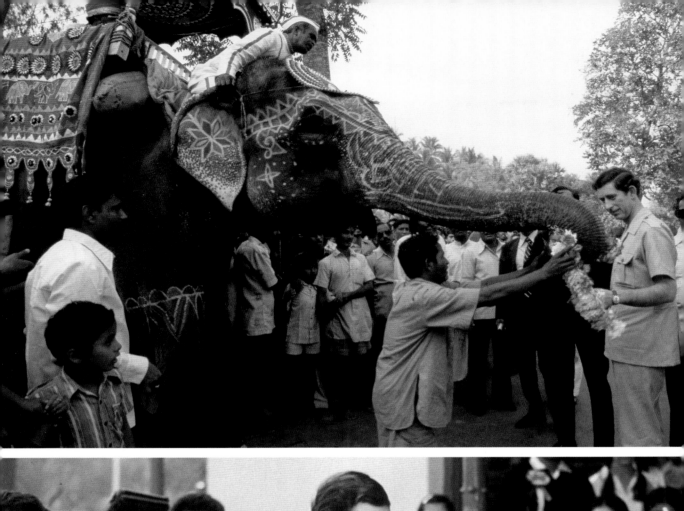
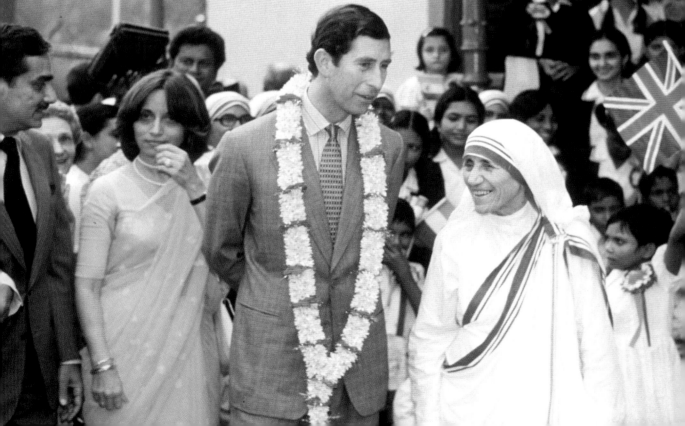

TRUNK CALL
FOR CHARLES

DECEMBER, 1980

Prince Charles came face to face with a jumbo-sized problem... in the shape of a five-ton elephant called Laxmin.

Villagers at Pipli in north-east India were determined to meet the Prince on his eastern tour.

So, they set up Laxmin as a mammoth roadblock, dressed in her best finery.

It worked. The Prince stepped smiling out of his car to see the 75-year-old elephant – who nearly hit him with her trunk. Charles ducked and said: "That was a close call!"

On the last stop of his tour, he met Mother Teresa, who won the Nobel Peace Prize in 1979 for helping the destitute and the dying of Calcutta.

The emphasis of this royal trip had been on India's achievements and the Prince kept his nose close to the grindstone of industrial India.

But in Calcutta Charles witnessed India's searing poverty.

He held a 20-minute meeting with Mother Teresa behind closed doors. Later he was said to have been deeply moved by a young boy at the Shishu Bhavan orphanage.

Social worker Sunita Kumar said: "The Prince of Wales attended a song and dance programme. He enjoyed it. Then at the end something inexplicable happened. One of the young boys who had performed caught hold of his leg and refused to let go. Initially taken aback, Charles gently put his arms around the boy and was moved to tears. We were all left with tears in our eyes."

Charles has visited India ten times since his first trip in 1980.

69

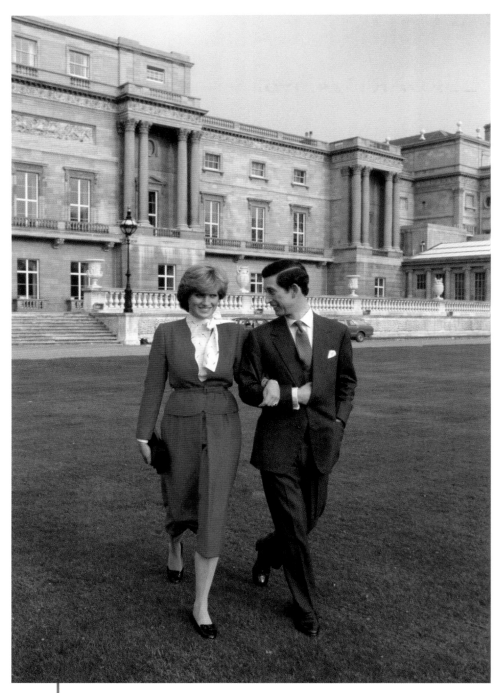

*Lady Diana Spencer and Prince Charles pose for photographers
at Buckingham Palace after announcing their engagement.*

MY SHY DI

FEBRUARY 24, 1981

The look of love was there for the world to see... as Prince Charles presented the girl he would marry. Lady Diana Spencer, 19, and the 32-year-old heir to the throne stepped out together in the grounds of Buckingham Palace – just hours after their engagement was announced.

Shy Di smiled and blushed as she displayed her dazzling engagement ring – an oval sapphire surrounded by 14 diamonds set in 18-carat white gold.

And there was no disguising her love for the Prince as she looked up at him tenderly and said: "I think I coped all right."

Clutching Diana's hand, Charles described the proposal a couple of days before Di left on a trip.

"I asked her before she went to Australia, because I thought she could think about it if she was unsure. But she replied straight away."

Asked how she would cope with the "tremendous change from nanny to future queen", Diana said: "I've had a small run up to it all in the last six months. Charles and I can't go wrong."

Her blue eyes lit up as she described how the couple met. "It was 1977, Charles came to stay for a shoot, we met in a ploughed field."

Charles added: "I remember thinking what a very jolly and attractive 16-year-old she was. I didn't know what she thought of me."

Diana said: "Pretty amazing."

Over the next three years the couple's love grew.

"Gradually. Towards the end of summer last year. I began to realise what was going on in my mind and hers," Charles recalled. "I had a long time to think about it. It wasn't a difficult decision."

Diana asked what she was going to miss about her old life.

"I'm going to miss looking after the children," she said.

Asked to sum up how he felt, Charles said: "Delighted, and happy. I'm amazed she's been brave enough to take me on."

"And in love?" asked a journalist.

Diana replied: "Of course."

Charles added smiling: "Whatever in love means."

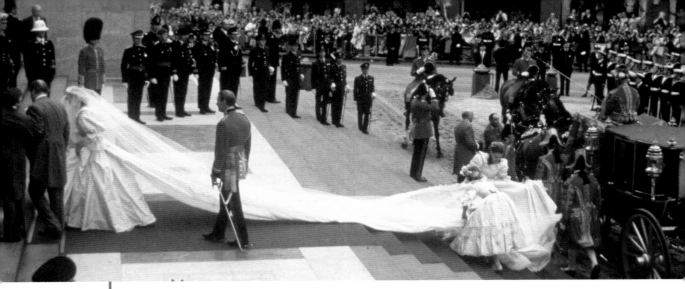

The train now arriving at St Paul's.

WEDDING OF THE CENTURY

JULY 29, 1981

When the cheers died away and the fanfares faded, one man and one woman knelt down together for God's blessing on their marriage.

For a few moments Charles and Diana were lost in the solemn pledges they were making. For them, the world vanished. They might have been alone in the sight of God.

The 750 million TV viewers watching them around the globe and the 2,500 witnesses in the congregation were, for a while, outside their private dedication to each other.

There was only one teeny slip-up when the bride fluffed her lines.

Did the bridegroom then deliberately stumble over his to make her feel better?

And wouldn't that have been just the nicest way to begin to love and to cherish his fair Princess?

From the moment the bride entered St Paul's Cathedral to the soaring strains of the Trumpet Voluntary, all eyes were on her.

One look at the bridegroom as he saw Diana come floating towards him in her Tudor princess gown told everything about his love for her.

The ivory sheen of her rustling silks gained a candlelit glow from the golden mosaics above her head.

Diana wore a fairytale dress for a fairytale Princess. Britain's best-kept secret was revealed as a radiant Lady Diana stepped from the glass coach at St Paul's.

The dress had everything. Frills, flounces, pearls and a crinoline skirt. Plus, a lace-trimmed train that just went on and on.

In all it measured 25ft from tiara to tip.

The gown, created by youthful husband and wife David and Elizabeth Emanuel, was perfect for the bride's model figure.

They hurried around her as she arrived, smoothing out lines and fluffing up skirts.

A tiny 18ct gold horseshoe was sewn into the skirt for good luck. Diamond drop earrings were Diana's only jewellery.

Bridesmaids India Hicks, Sarah-Jane Gaselee, Clementine Hambro and Catherine Cameron wore ballerina dresses based on the bridal gown.

The pages, Edward van Cutsem and Lord Nicholas Windsor, were in full dress Royal Naval cadet's uniforms from 1863, complete with the gold hilted dirks.

Charles's eyes never left Diana's during the service. Despite her nerves during her vows, she smiled at her sisters, giggled at her groom, and finally sank down into the most perfect curtsey to her new mother-in-law, the Queen.

With her veil thrown back, the first Princess of Wales in over 70 years tucked her arm into her husband's and went out to show the world her happiness.

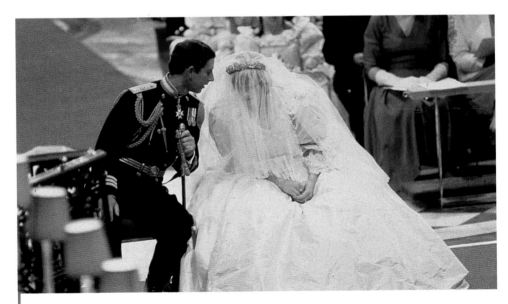

Diana and Charles's wedding was watched by 750 million people around the world.

I'M A DAD

JUNE 21, 1982

Charles and Di took their baby son home from hospital, just 21 hours after his birth.

The huge crowd outside St Mary's Hospital, Paddington, roared themselves hoarse as the tiny Prince made his first public appearance.

Prince Charles emerged first from the private Lindo Wing cradling his son in his arms.

The baby was warmly wrapped in a white shawl to protect him from the evening air.

His face and the top of his head could be seen peeping out from the covers.

Princess Diana walked closely behind, looking a picture in an emerald green dress and pink shoes.

Proud Charles had watched the birth of his first son and said: "Isn't he the most beautiful baby you ever saw?"

Our newest royal weighed in at 7lb 1oz and with big blue eyes to bring joy to Princess Di... and a waiting nation.

The baby arrived at 9.03 after Diana had been in labour for more than 13 hours.

Tender Charles never left his wife's side – and the verdict from everyone afterwards was: Di you were terrific... well done Mum!

The baby – second in line to the throne – announced his appearance by crying lustily.

Minutes after the birth, Charles was cradling his son in his arms.

The royal couple were then given half an hour alone with their precious bundle of joy.

The Queen was "absolutely delighted" with her latest grandchild – whom Di had said was due on July 1, her 21st birthday.

On the night of his son's birth, Charles, with tears of joy in his eyes, was asked about the baby's name and admitted – "There's an argument about it. I dare say we shall find out in a day or two."

Diana cradles her firstborn son, the future King of England, as they leave hospital with Prince Charles.

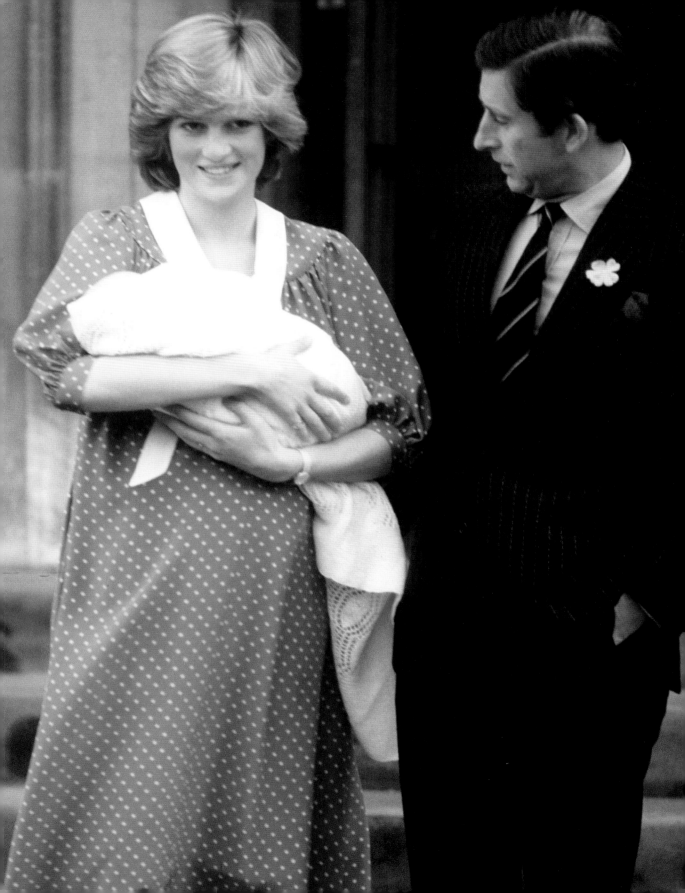

STAND-UP COMIC

APRIL 23, 1983

Prince William Arthur Philip Louis put on a Royal Command performance – as a stand-up comic.

He went on show to photographers from all over the world and had them roaring with laughter.

He stood on his own feet for the first time, but there was more to come in the one-baby show in Auckland, New Zealand.

He also grinned away while crawling on the rug put down on the lawn at Government House, revelling in the joy of self-propulsion.

He kept crawling to the edge of the rug.

The royal joker's feet were only tiny... but they took a big step down the road to growing up.

Princess Di helps William stand up for the first time.

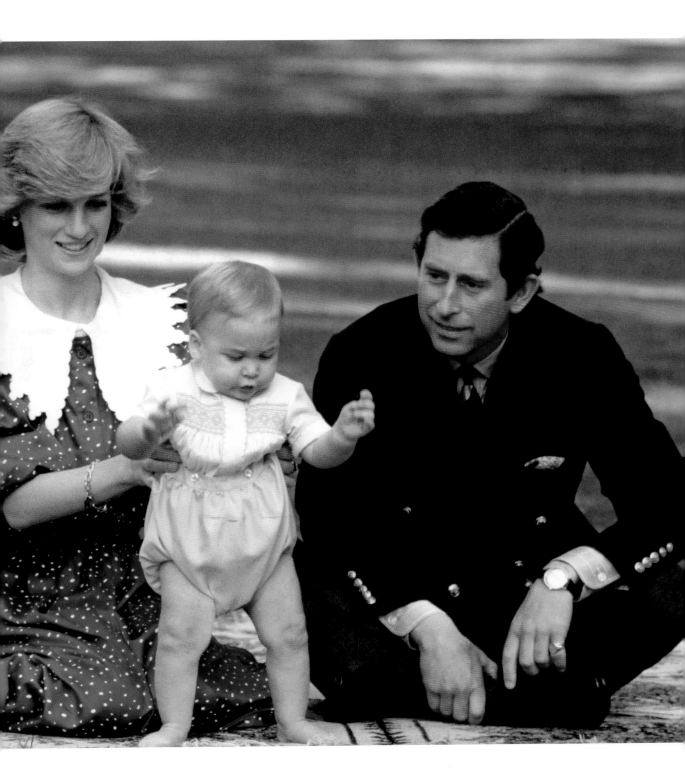

MOTHER'S PRIDE

DECEMBER 15, 1983

There was no mistaking a mother's look of love as Princess Di showed off her little son William to the world.

Di's eyes shone with pride as she watched the rosy-cheeked Prince – snug in his smart snow-suit – go toddle about for a posse of press photographers.

And she laughed happily as 18-month-old William grinned and pointed at the battery of clicking cameras.

Now and then she exchanged delighted looks with Prince Charles as they watched their son turn on his royal superstar act in the garden of London's Kensington Palace.

Charles and Di had been careful to protect their son from too much press attention. This time though, they were glad to take a back seat as William turned on the style.

It was only the second time he had faced the cameras for an official photocall but he took the whole thing in his stride.

And when the little Prince decided it was time to go, he ended the photocall with a wave and trotted off... with mum and dad in hot pursuit.

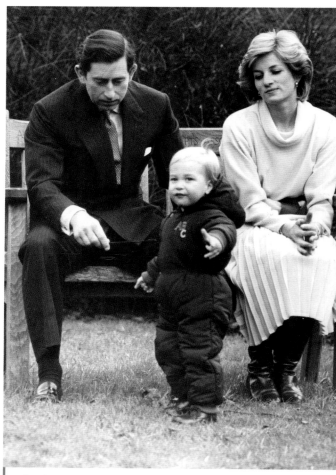

Charles and Di keep a loving eye on William.

A MONSTROUS CARBUNCLE

MAY 30, 1984

Prince Charles blasted modern architecture and described a proposed new extension to the National Gallery as a "monstrous carbuncle".

He was speaking at the Royal Institute for British Architects' 150th anniversary dinner at Hampton Court.

But rather than say "Happy Birthday" he delivered a ferocious attack on modern designs.

He said the designs for the art gallery were like "a monstrous carbuncle on the face of a much-loved and elegant friend."

He added: "For far too long some planners and architects have consistently ignored the feelings and wishes of the mass of ordinary people in this country. A large number of us have developed a feeling that architects tend to design houses for the approval of fellow architects and critics, not for the tenants.

"The same feelings have been shared by disabled people who consider that with a little extra thought, consultation and planning, their already difficult lives could be made less complicated."

The Prince asked for respect for old buildings, street plans, and traditional scale.

The heir to the throne was not a big fan of brutal-looking buildings or knocking down old ones.

He had spoken of being inspired to criticise design by visiting British towns as a young man in the 1960s, where he felt property had been demolished with no thought for tradition or heritage.

ONCE UPON A TIME THERE LIVED A PRINCE

SUMMER, 1984

"Not all that long ago, when children were even smaller and people had especially hairy knees, there lived an old man of Lochnagar."

Much to the amusement of young book lovers, Prince Charles, in a kilt and fair isle sweater, read a story on BBC children's show Jackanory.

The Old Man of Lochnagar was a tale made up by the Prince himself to amuse his younger brothers Andrew and Edward.

It was published as a storybook in 1980, with illustrations by Sir Hugh Cassons, an artist who designed the interiors of the Royal Yacht Britannia and who is said to have taught Charles to paint with watercolours. The proceeds of the book went to The Prince's Trust to support young people into work.

The tale told of an old man who leaves his cave in the cliffs to roam the hills and lochs of the Grampians. He interacted with characters such as a grouse who repels visitors, underwater haggis who revolve as they swim, the miniature green people of Gorm, and the birds and fishes who live in the skies and lochs around Balmoral.

He even had a toilet made of bagpipes.

Charles and the Jackanory team filmed the episode on Lochnagar, the mountain that overshadows Balmoral.

Director Victoria Secombe said: "Normally we want actors to be giving us their best and feel comfortable. He was doing that to us, making us laugh, telling us stories about Prince William and making us feel at ease."

The young viewers seemed thrilled to have a real-life prince telling them a story.

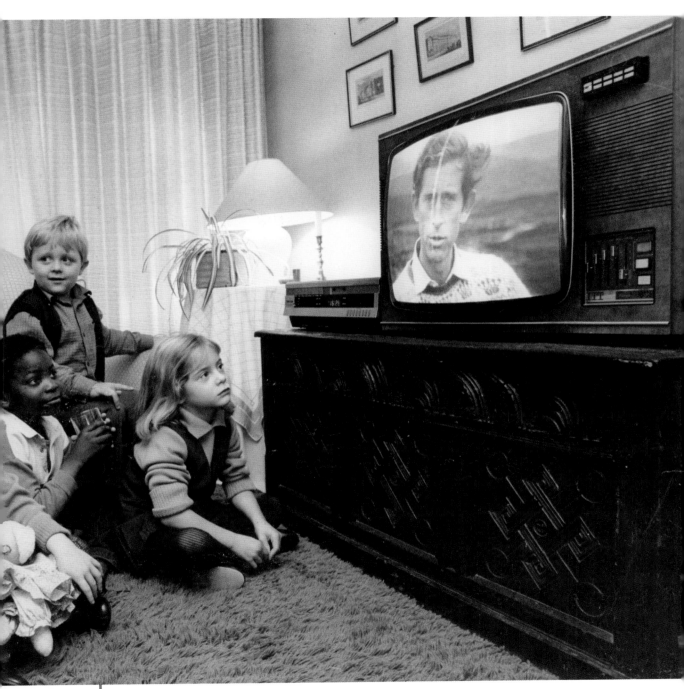

Charles's book was adapted into an animated short film by the BBC, with Robbie Coltrane voicing the hermit and the Prince narrating. The book was turned into a musical in 1984.

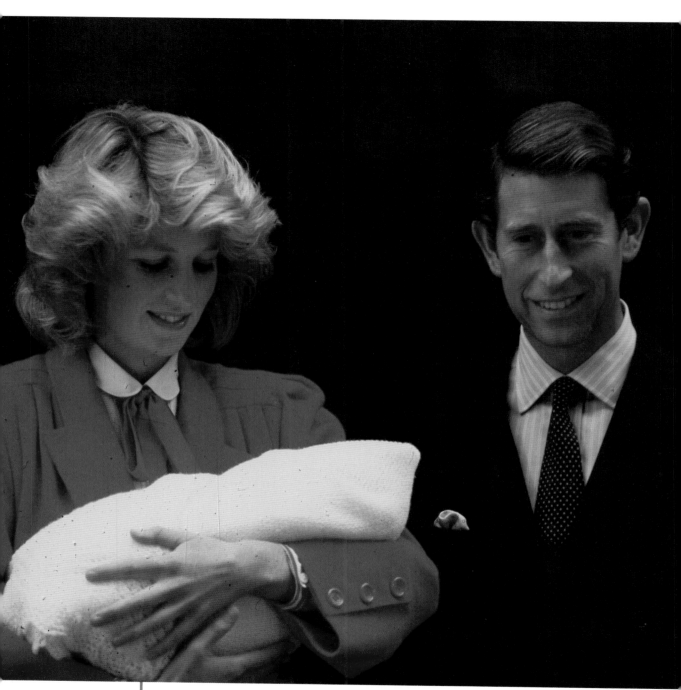

That's our boy... Prince Charles and Diana take their baby son, Harry, home.

I'VE NEARLY GOT A FULL POLO TEAM

SEPTEMBER 15, 1984

Smiling Princess Diana got her adoring public's verdict on her baby Prince: "Hooray for Henry!"

The royal infant – to be christened Henry Charles Albert David – made his debut cradled in her arms as she left St Mary's Hospital, Paddington.

The tiny tot was almost covered in a white shawl until a wisp of pale hair emerged.

Proud Prince Charles told cheering crowds: "I've nearly got a full polo team."

The beaming Prince was speaking just two hours after the birth of his second son.

As he left the hospital, he shook hands with well-wishers and said: "My wife is very well.

"The delivery couldn't have been better. It was much quicker this time."

Diana gave birth to a brother for Prince William at 4.20pm. Charles immediately rushed to telephone the Queen and Di's family.

A Buckingham Palace spokesman said all the Royal Family were delighted.

The new prince, who was third in line to the throne, weighed 6lb 14oz.

The birth took place in the fourth-floor room where William was born in 1982.

Charles told the crowd of forty who waited outside: "It was really exciting being there, it was a great moment. Now I want to go home and get drunk."

The Prince said his new son – who quickly became known as Harry – had pale blue eyes and hair of an "indeterminate" colour.

"He's looking better by the minute."

Princess Diana exercised a woman's privilege by keeping an expectant world waiting longer than doctors anticipated.

She was driven to hospital with Charles at 7.30pm. Doctors expected a six-hour labour.

In fact, the baby took nine hours to arrive.

ROYAL FLASH DANCE

MARCH 29, 1985

Prince Charles became the disco king when he cut loose on a youth centre's dance floor.

Charles swayed to the beat as youngsters cheered at Middleton-on Sea, West Sussex. Then he really got into the spirit... dropping to his knees in a breakdance.

Wearing a suit, tie and smart shoes, the royal raver got into the rhythm with a little help from an expert.

The Prince's fancy footwork left others reeling with admiration. Fellow bopper Dwayne Smith said: "He's very good."

Charles was visiting 300 jobless youngsters on a training course organised by The Prince's Trust. And a new Prince of Pop was born!

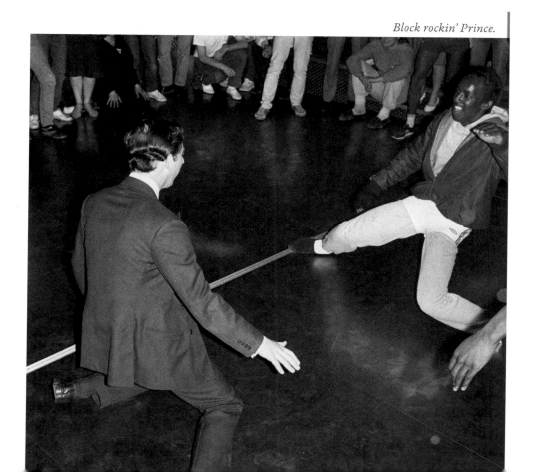

Block rockin' Prince.

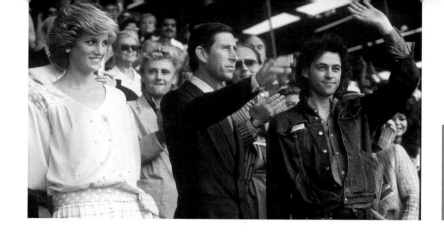

Charles and Diana alongside Live Aid organiser Bob Geldof.

STARS OF LIVE AID

JULY 13, 1985

Prince Charles and Princess Diana lit the touch paper for the biggest rock concert in the world when they officially opened Live Aid.

The 16-hour worldwide super concert organised by Bob Geldof started in London's Wembley and continued at JFK Stadium in Philadelphia.

The roar of 82,000 pop fans as Charles and Di took their seats in the royal box was deafening. They sat alongside big-name rock stars David Bowie, Elton John, Brian May, Phil Collins and of course the Boomtown Rat himself.

Geldof's wife Paula Yates remembered to stop at a petrol station on the way to Wembley to buy flowers for the Princess.

The concert was beamed by satellite to more than a billion TV viewers in 110 nations.

Later Charles made a personal donation to Bob Geldof's Live Aid fund.

The exact amount was kept secret, but it was understood to be a four-figure sum.

His generous gesture likely inspired more people to dig into their pockets for famine relief in Ethiopia.

Already more than £40 million had been pledged worldwide and experts believed the fund could top £150 million – the most successful charity appeal in history.

The Prince told *The Sun* later: "Bob missed his vocation in life – he should have been a general."

The royal couple did a considerable amount of charity work, but personal donations were rare in case they were accused of favouritism. A close aide said: "The Live Aid famine appeal is an exception."

THE KING OF SWING

JANUARY 28, 1988

Swinging Prince Charles danced Princess Di off her feet... until she gasped for breath and begged him: "Slow down."

Giddy Diana was whirled around a Melbourne ballroom to the tune of Glenn Miller's In The Mood – and the future King certainly was.

He was like a teenager at the Palais on a Saturday night as he boogied with his beautiful wife.

"Steady – take it steady." Diana told him. But there was no slowing down Charles.

He was making up for a night in the same Australian city just over two years previously when he and the Princess had danced to the number "Isn't She Lovely?"

That time Charles came under fire for being too staid and square.

But as the band struck up "In The Mood" the Prince was clearly having a ball.

And 500 VIPs who packed into the dinner-dance to celebrate Australia's 200th birthday loved every minute of it.

Diana looked sensational in a figure-hugging royal blue and pink Catherine Walker gown slit to the thigh, offset by a sapphire and diamond necklace. She entered into the spirit of the dance once she caught her husband's devilish mood.

He did not have the same hip-swinging style of John Travolta who partnered Diana at the White House two years before.

But "old fashioned" Charles made up for that with sheer enthusiasm.

Earlier Charles had been mobbed when he visited homes in the city's old port district.

Some middle-aged women tried to hug and kiss him.

And Charles said: "I'm loving every minute."

Prince Cha-Cha-Charles impresses VIPs with his footwork.

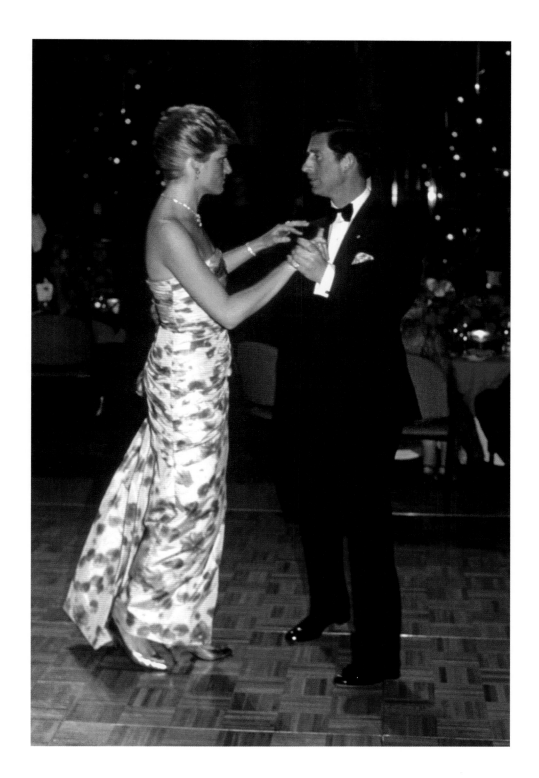

HELL ON THE SKI SLOPES

MARCH 10, 1988

In a remarkable statement, Prince Charles spelled out exactly how close friend Major Hugh Lindsay died in a horrific avalanche.

The document revealed every moving detail of the ski horror that almost buried the heir to the throne in tonnes of snow and cost his friend's life.

Two days after the devastating event he told how he dug with bare hands to help free his pal Patti Palmer-Tomkinson after she was covered by the avalanche in Klosters, Switzerland, and tried to save his friend.

He said the entire party accepted that they were skiing off piste at their own risk.

He described dodging the "whirling maelstrom" which swept Hugh and Patti away. "The whole mountainside seemed to hurtle past us," he said.

The Prince revealed that guide Bruno Sprecher reacted with "incredible speed" and raced to give Patti the kiss of life.

Charles comforted pain-racked Patti, whose legs were broken, while Bruno tried in vain to revive Hugh.

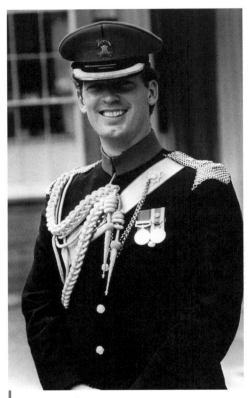

Major Lindsay

Princess Diana had stayed in the chalet with a heavy cold that day. The Duchess of York returned to the chalet after a fall on the slopes.

Without them Charlie and Patti Palmer-Tomkinson, Major Lindsay, a former equerry of the Queen, and Charles

attempted the Haglamadd, a difficult unmarked ski run. Racing down, they heard a great roar of noise, and gigantic slabs of snow, each one the size of a large room, were crashing towards them.

Charles and Charlie Palmer-Tomkinson, a former Olympic skier, jumped to safety but Patti and Lindsay had been buried. She was saved. Hugh's body was recovered later.

Charles's scribbled account – in blue felt-tip pen on headed Prince of Wales notepaper – was read out at Zurich airport moments before the royal party boarded a jet for home. Major Lindsay's coffin was put on the same plane at the Prince's request.

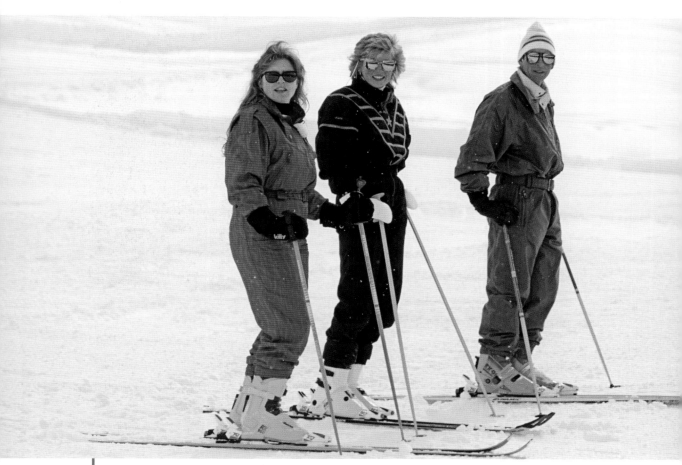

The Duchess Of York, Princess Diana and Prince Charles at Klosters before the tragedy.

I WAS A SILLY FOOL

JULY 3, 1990

Prince Charles put a brave face on breaking his arm in a polo accident and admitted it was "a silly thing to do – I was a silly fool."

A Buckingham Palace spokesman said: "He is in reasonably good humour as much as anyone could be with a fairly serious fracture. He said it was silly."

The fall came as Charles dashed on his pony Echo to defend the goal for his team, Windsor Park.

They were one down against Hildon House in the second chukka at Cirencester Park, Gloucestershire, when Charles went after a ball with Hildon's Mike Amoore.

Eyewitness Jim Gilmour said: "They were going for the ball at speed when Prince Charles fell heavily on his right arm. It was a clean break just above the elbow."

Team manager Major Ronald Ferguson, father of Sarah, followed with a police escort as Charles was taken by ambulance to Cirencester Memorial Hospital, two miles away.

An operation pulled his arm into line and straightened his bone.

The Prince was kept in for observation overnight and Princess Diana picked him up the next day.

The Queen was told of her son's accident – which was bound to have renewed calls for Charles to hang up his mallet.

This was his third polo accident. He has collapsed with dehydration during a match in Florida and was kicked in the face by a horse.

He first played when he was 15, in a team captained by his father. He later represented Cambridge University in his favourite sport.

Charles's polo injuries over the years meant he suffered from back pain. Prince Harry claimed he clasps his hands behind his back to relieve stress when walking.

END OF THE FAIRYTALE

DECEMBER 9, 1992

Prime Minister John Major formally announced the separation of the Prince and Princess of Wales.

He told the House of Commons: "It is announced from Buckingham Palace that, with regret, the Prince and Princess of Wales have decided to separate. Their Royal Highnesses have no plans to divorce, and their constitutional positions are unaffected. This decision has been reached amicably and they will both continue to participate fully in the upbringing of their children."

The historic announcement came six months after the publication of the explosive book Diana: Her True Story, which blew the lid on the royal fairytale.

Author Andrew Morton alleged deep unhappiness in the relationship. It claimed the Princess was locked in a loveless marriage while the Prince had an affair with old flame Camilla Parker Bowles.

In devastating detail, Morton claimed Diana had suffered from bulimia and had made suicide attempts.

The book appeared to have the Princess's tacit approval.

Despite Palace denials, the copyright for the cover's striking portrait by photographer Patrick Demarchelier was owned by Diana herself.

In the aftermath of the publication, the Princess bluntly told Charles she would not bow to Palace pressure and declined to join him on a November tour of Korea.

Diana refused because she was "livid" that the Palace PR machine planned to use the visit to pretend the Wales's marriage problems were over. The Queen however insisted.

The plan backfired when the couple behaved almost as strangers in Seoul.

Increased speculation about their relationship became fact with the Prime Minister's announcement.

Charles and Diana in Seoul. Andrew Morton later revealed Princess Diana had cooperated fully with his book, recording answers to his questions via an intermediary.

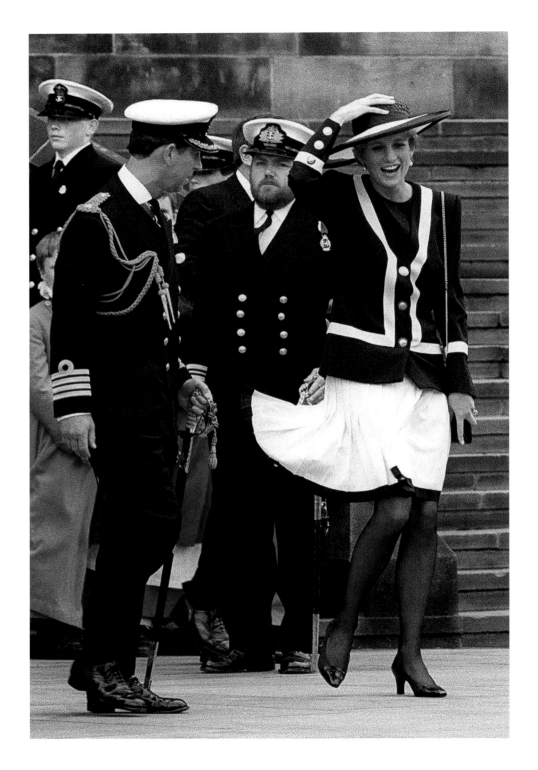

CHARLES AND DI EQUALS SMOKE AND MIRRORS

MAY 30, 1993

Princess Di got a fit of the giggles as the blustery wind flipped up her skirt on her first public date with Charles in five weeks.

The warring couple put on an uneasy show of togetherness as they arrived in the same car for a service in Liverpool marking the Battle of the Atlantic. They chatted and even laughed. The couple had barely spoken since they split six months previously.

But when a pensioner in the crowd outside the city's Anglican Cathedral shouted: "It's wonderful to see you again," Charles replied, "It's all done by smoke and mirrors, I promise."

The couple kept up the double act by going on a joint walkabout, instead of taking opposite sides of the street.

When the wind caught Di's skirt, she nearly lost her hat as she grabbed for the hem to preserve her modesty.

An aide grabbed her handbag as it almost fell to the pavement. Di giggled: "I'd have never worn this if I'd known it was going to be this windy. This is real Atlantic weather."

The engagement was only the couple's third together since they separated in December 1992.

The royal couple had lunch aboard the Royal Yacht Britannia for 100 Navy veterans. Then they flew back to Heathrow on the same plane.

There the togetherness ended – Charles and Di went their separate ways in different cars.

Breezy does it; Diana holds on to her hat as she chats with Charles.

COOL CHARLES STARES DOWN GUNMAN

JANUARY 26, 1994

For 45 years Prince Charles had been trained for the moment a gunman would try to take him out.

When David Kang fired a shot, Charles stood his ground bravely. He never flinched and stared directly at the assailant rushing towards him.

Another shot rang out – and still, Charles stayed ice cool.

Ten thousand Australians watched in horror as Kang was bundled to the ground by onlookers. Charles simply fiddled with his cuff links.

The Prince shrugged off the incident in Sydney and told officials: "Don't worry. These things happen."

Political activist Kang saw himself as a crusader who wanted the best for his people. But he could have changed the course of history.

The 23-year-old sat in silence as Charles arrived at Tumbalong Park to celebrate Australia Day.

As the Prince took to the stage, Kang pulled out a JEX 202 model starter's pistol then sprinted towards the stage.

He knocked a small girl out of the way as he raised his gun in the air. The crowd gasped as a cracking noise rang out and smoke belched from the barrel.

Charles had just stood up. He did not move as the shot rang out.

He didn't duck when Kang scaled the stage and raised the gun to let off another shot.

Royal bodyguard Colin Trimming was out of his chair heading for the gunman but by the time he reached Kang, members of the crowd had already grappled him to the ground.

A bodyguard shields the Prince of Wales during a gun attack in Australia. Kang was later found guilty of threatening violence, in a Sydney court.

96

Charles with Jonathan Dimbleby.

DI TOLD YOU SO

JUNE 29, 1994

Princess Diana took revenge on her husband with a dress that screamed "look what you're missing" after Prince Charles's sensational adultery confession.

The heir to the throne's admission of an affair was screened on ITV as Diana arrived at a Vanity Fair party.

Her black low-cut figure-hugging mini dress by Greek Designer Christina Stambolian was everything a royal woman should not have worn but the Princess held her head high as she walked the gamut of photographers at London's Serpentine Gallery.

On the same evening, millions watching the TV documentary Charles: The Private Man, The Public Role, heard the Prince confess he had been unfaithful after deciding his marriage had irretrievably broken down.

Hard-hitting foreign affairs journalist Jonathan Dimbleby said to him: "The most damaging charge in relation to your marriage is that you were persistently unfaithful to your wife and caused the breakdown of your marriage. How do you respond?"

Charles replied: "There is no truth in so much of this speculation. Mrs Parker Bowles is a great friend of mine. She has been a friend for a very long time and will continue to be a friend. When marriages break down... it's your friends who are the most helpful and encouraging and supportive."

Dimbleby pressed: "When your

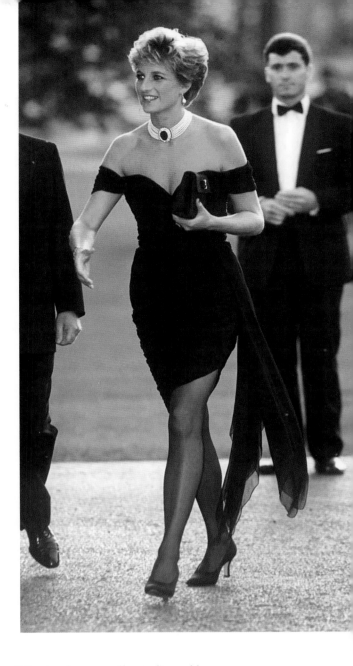

When Diana gave her first solo interview to Martin Bashir in November 1995, she revealed further shocking details about the tortured relationship and memorably noted: "there were three of us in this marriage." The Queen urged Charles and Diana to divorce quickly. They agreed a settlement in August 1996.

marriage collapsed you reestablished close friendships of whatever character that friendship is. Did you try to be faithful and honourable to your wife when you took on the vow of marriage?"

Charles said: "Yes absolutely... until it became irretrievably broken down. Us both having tried."

Those close to Diana said the admission brought her an enormous sense of victory and relief. Her claims about her husband had been verified.

The Princess suspected throughout her marriage that Charles had been cheating on her with Camilla and took this as implicit confirmation she was right.

Di had gone public with her fears by authorising leaks of her views on Charles's mistress.

A friend said: "This is a tremendous relief to Diana. But she does not want to rake it all up again and start crowing because she is thinking of her sons.

"She has been totally vindicated by Charles's confession.

"When Andrew Morton's book Diana: Her True Story came out, there were many people who said she was manipulative. But she was being honest."

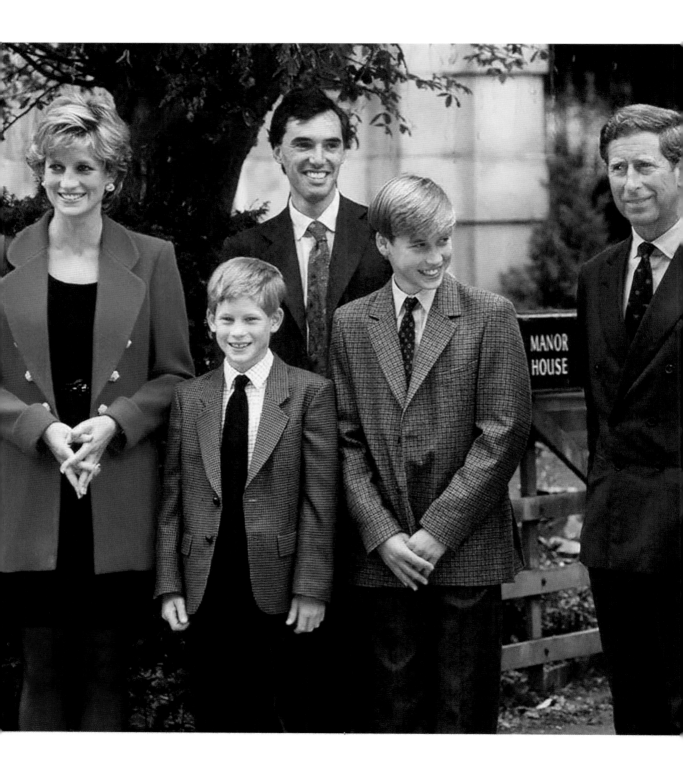

TOGETHER FOR WILLS' FIRST DAY AT ETON

SEPTEMBER 6, 1995

Mum and Dad dropping you off on your first day at school is a rite of passage experienced by most children.

But most children are not normally accompanied by the world's press and a crowd of fans.

That was the scene when Prince Charles and Princess Diana put their relationship issues to one side to take Prince William to enrol at Eton College.

The separated couple and brother Prince Harry walked William up to the gate of Manor House, where they were met by Andrew Gailey, who would be Wills' house master.

Harry clutched his mum's little finger as the family walked from Manor House to the main school hall, where left-handed William signed the register.

His uniform would include a tailcoat, waistcoat and pin-striped trousers.

Charles and grandfather Prince Philip had attended Gordonstoun boarding school in Scotland but Princess Diana's brother and father were both Eton alumni.

William's grandmother, Queen Elizabeth, took lessons at Eton in constitutional history.

An agreement was made between the press and the Royal Family to leave William alone during his time at Eton. The chairman of the Press Complaints Commission, John Wakeham, said: "Prince William is not an institution; nor a soap star; nor a football hero. He is a boy: in the next few years, perhaps the most important and sometimes painful part of his life, he will grow up and become a man." The press stuck to their agreement.

William left Eton with A-levels in geography, biology and history of art as well as 12 GCSEs. Harry followed his brother to the world-famous school two years later.

CAMILLA SPARKLES AT 50TH BASH

JULY 19, 1997

Camilla Parker Bowles sparkled in a diamond necklace at her 50th birthday party – a glittering bash stage-managed by Prince Charles.

Beaming Camilla wore the choker for the first time, sparking speculation it may have been a special birthday gift from Charles. He could have handed it to her when she dined with him on July 17, her actual birthday.

The Prince was keen to publicly celebrate the important birthday of the woman he had loved for more than 25 years.

Camilla wore a black sleeveless dress. She arrived at the Prince of Wales' Highgrove estate just after 7pm by chauffeur-driven limo from her home 15 miles away.

Then she stood side by side with the Prince as they greeted 30 close friends.

Charles's pal, former Armed Forces Minister Nicholas Soames, was among the first to arrive. Also there was Tiggy Legge Bourke, once Charles's Girl Friday and Prince William and Harry's former nanny.

Camilla's ex-husband Andrew Parker Bowles and his new wife Rosemary came with the children he had with Camilla – Laura and Tom.

Surveys had shown the public was warming to Camilla, with at least half happy about the relationship but most still wary about her becoming queen.

Camilla's car slows down for the press as she arrives for her 50th birthday party, thrown by Prince Charles at Highgrove.

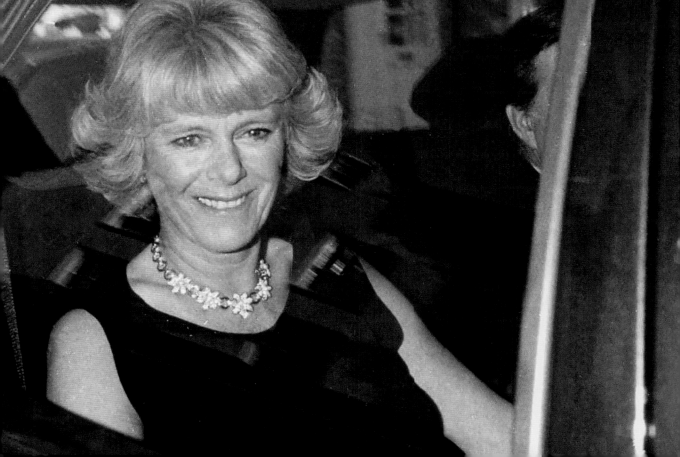

THE DEATH OF DIANA

AUGUST 31, 1997

The woman who once would have been Prince Charles's Queen died aged just 36 in a crash in Paris, leaving her two young sons and a shocked world grieving.

Diana, Princess of Wales, lost her fight for life at 4am in hospital, four hours after being injured in the accident. Her boyfriend Dodi Fayed, who had been with her in the back of the car, died at the scene.

The Queen and the Prince of Wales, who had divorced his wife a year previously, were woken at Balmoral and told of the tragedy.

A statement from Buckingham Palace, issued shortly after 4am, said: "The Queen and the Prince of Wales are shocked and distressed by this terrible news. Other members of the family are being informed."

Diana's sons, Princes William and Harry were woken by their father at Balmoral and told of their mother's death. They were understood to have been due to meet up with her.

The Princess died at the Pitie-Salpetriere hospital, close to the scene of the accident. A doctor who treated her said she had received serious head injuries and suffered a heart attack.

Sir Michael Jay, the British ambassador, was with her at her bedside.

Robin Cook, the Foreign Secretary, said: "I am shocked by the news and our first thoughts must be with the children and the family in this time of immense loss."

The Princess had become close to Egyptian playboy Dodi after his father, Harrods owner Mohamed Al-Fayed, invited Diana, William, and Harry on holiday in St. Tropez, where he had a four-acre estate, earlier in the summer.

In August, the couple had taken a romantic trip on Al-Fayed's yacht, the Jonikal, while the boys travelled to Balmoral to be with their father, Charles.

On the evening of the crash, Diana and Dodi were travelling from the Paris Ritz, owned by Al-Fayed, to Dodi's apartment near the Arc De Triomphe.

Henri Paul, the driver of the Mercedes Benz S280, was a security officer from

the Paris Ritz hotel. He also died in the accident. He was later found to have been three times over the French drink-drive limit and had had a high-speed chase with paparazzi.

The Princess's bodyguard, Trevor Rees-Jones, was cut from the wreckage and was seriously injured.

The accident took place in a short tunnel beside the River Seine near the Alma Bridge in western Paris, in sight of the Eiffel Tower.

Princess Diana leaves the Paris Ritz with boyfriend Dodi Fayed, hours later she would be dead. This picture was used at her inquest, which found the driver of her car had been three times over the drink drive limit.

Republican Guards stand to attention as the coffin of the Princess of Wales leaves a Paris hospital, after Prince Charles arrived to escort her body back to London.

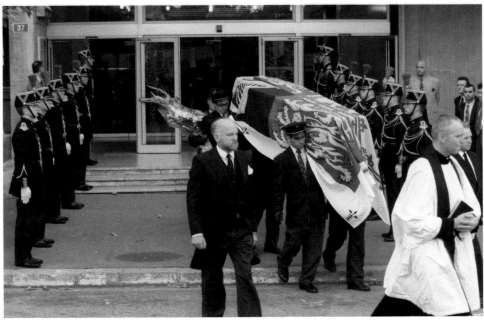

THE SADDEST DAY

SEPTEMBER 6, 1997

Devastated Prince William and his young brother Prince Harry showed their extraordinary courage as they watched their mum's coffin leave Westminster Abbey.

Under the gaze of their distraught father, the dignity and strength of the 15-year-old future King and Harry, 12, shone through.

A cruel twist of fate robbed them not only of their loving mother, but of their childhood.

But they set aside their anguish to lead the mourning for the woman whose death shocked the world.

The boys had escorted Princess Diana's coffin to the abbey, braving the tear-stained gaze of many of the two million people who flocked to London to pay their last respects.

The children's pain was revealed as they flanked Prince Charles in the church in front of 2,000 guests, including statesmen and showbiz stars.

Charles himself was the first to show his tears after he laid a wreath for his ex-wife.

Another from Prince Harry rested on Diana's coffin. It bore the simple hand-written message: "Mummy."

Gone from the children's faces was the mask of royal duty they wore on public appearances at Balmoral and Kensington Palace.

William, who stood 6ft 1in, had already emerged as a boy-turned-man.

He showed the same characteristics of his mother – lowering his head while his eyes gazed nervously.

Every so often, William raised a finger to his brow – the Royal Family trait of hiding their true emotions from prying and unwelcome eyes.

But there was no disguising his torment.

Harry could barely take his eyes off his mother's coffin as he sat just six feet away.

Trying, like his brother, to hide his grief he raised his hand to wipe his brow as the congregation sang the first hymn, I Vow to Thee, My Country.

But it was when Elton John sang his reworked version of Candle In The Wind that Harry buried his face in his hands and sobbed.

After Diana's burial, her sons were driven to Highgrove. The next day Charles took the boys to morning service at a local church.

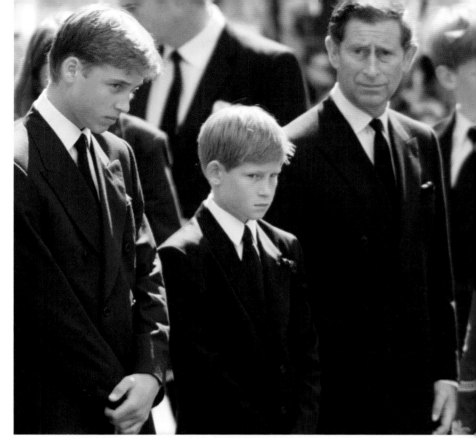

The Prince of Wales casts a concerned glance towards sons Prince William (left) and Prince Harry as they wait for the coffin of Princess Diana to be loaded on to a hearse outside Westminster Abbey.

Prince Charles with Prince Harry; Charles, Earl Spencer; Prince William and Prince Philip following the coffin carried by soldiers of the 1st Battalion, Welsh Guards into Westminster Abbey.

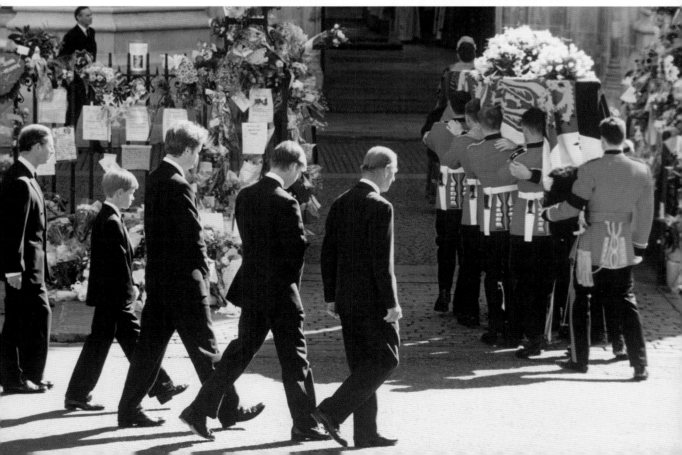

CHARLES SPICES UP HIS IMAGE

NOVEMBER 1, 1997

Prince Charles declared it the "second best day of my life". President Nelson Mandela said it was "one of the greatest days of my life." And the Spice Girls, Britain's pop sensation, tottered on platform shoes alongside the two statesmen, giggling with delight.

Under cloudless South African skies, the future British King, one of the world's most charismatic politicians and the all-girl band formed an unlikely alliance to perform for the world's media at Mandela's official residence in Pretoria, one of the country's capitals.

Regarded as the highlight of the Prince's first official tour since the death of Diana, the performance on the lawn outside the Mandela home was startling because everybody seemed happy and relaxed.

The photocall – staged before a charity concert which was attended by Charles and his son Prince Harry – was the first demonstration of moves to make the heir to the throne appear more human to a cynical press and public.

To the delight of the 100 journalists and photographers covering his seven-day tour of Southern Africa, Charles and Mandela grinned broadly as they were asked how it felt to be so close to five beautiful young women.

"I do not want to get emotional about it," said Mandela, clutching Geri Halliwell and Emma Bunton. "These are my heroes and this is one of the greatest days of my life."

After announcing this was the second-best day for him, Charles said his best day was "meeting them the first time."

Mandela said his relationship with Charles was "very special".

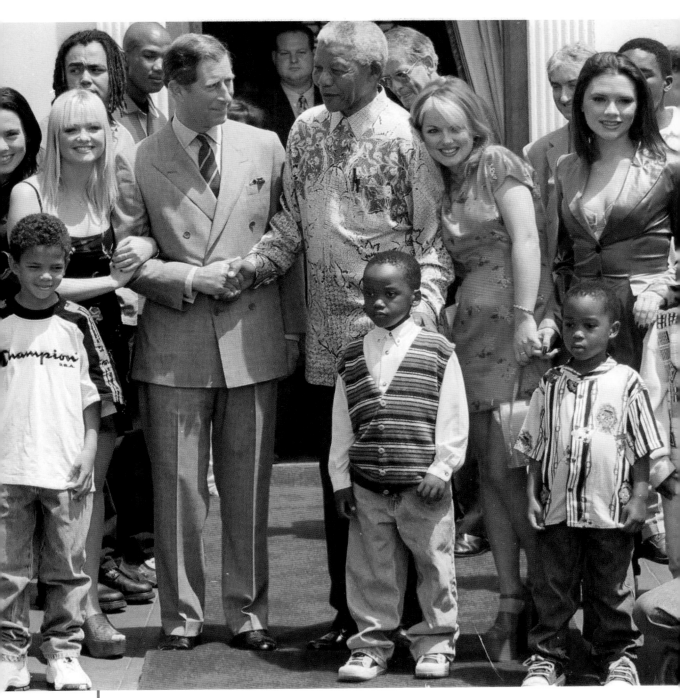

Scary, Sporty, Baby, Prince Charles, President Mandela, Ginger, and Posh with South African children.

MEET THE MISTRESS

JANUARY 28, 1999

History was made as Prince Charles publicly posed with the woman he had loved for 25 years.

Flashguns lit up the night outside London's world-famous Ritz hotel as Charles walked out of the doors with Camilla at his side.

The world's first sight of the couple together was as they stood arm-in-arm at the top of the steps. Hundreds of cameras clicked and whirred, and the couple then unlinked their arms before walking down to their waiting car.

A crowd of more than 300 well-wishers cheered and whooped, yelling: "Well done, Charles and Camilla."

The build-up had begun almost 20 minutes earlier as Camilla chatted with her son Tom and daughter Laura outside the hotel's Marie Antoinette Suite.

They had spent the evening there at the 50th birthday of Camilla's sister Annabel Elliot.

Camilla, stunning in a black dress coat and cocktail dress, began pacing up and down as she waited for Charles to finally emerge and smile knowingly at her.

Then the lovers, along with Tom and Laura, walked the 65 steps through the Long Gallery of the Ritz towards the entrance.

Charles chatted reassuringly to Camilla, who had a broad grin.

As they reached the door, they turned and kissed Tom and Laura.

Royal bodyguard Inspector Ian McCrae emerged first and walked down the six steps to the pavement.

Charles and Camilla stood facing the cameras at the top.

For a second it seemed that Camilla almost lost her nerve as she appeared to hide behind the Prince.

But he gently guided her by the arm to the open door of a dark green Vauxhall Omega saloon. Within seconds they were gone, back to nearby St James's Palace, both smiling broadly.

Camilla later told friends she was "absolutely delighted and relieved" to have got through the photocall.

Her nervousness had grown throughout the party – and was made even worse because Charles was late.

While she arrived at 8.45pm, he did not get there until 10.55pm having

been delayed at a reception for Egyptian diplomats.

The Prince also decided to walk to the Ritz from St James's Palace because traffic was bad.

Not since the days of Di-mania and her funeral had there been such a frenzy of activity over a royal event.

For almost 48 hours, photographers arrived with ladders to mark off their pitches on the pavement outside The Ritz.

TV crews with satellite dishes parked in nearby streets hooking up to expensive live links to every corner of the world.

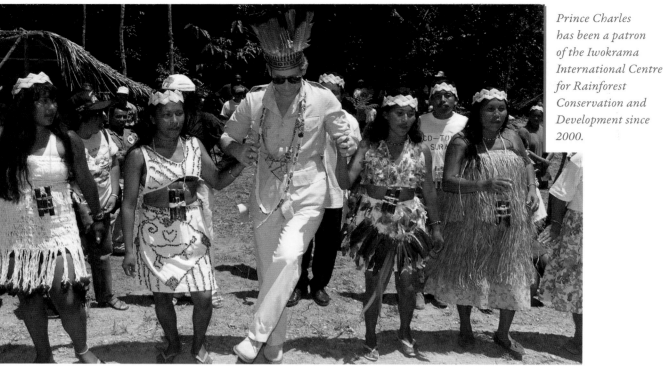

THE HEIR TO THE FLOWN

FEBRUARY 27, 2000

Prince Charles was wing for a day as he sported an eagle-feather headdress.

The gift came as he was made a tribal chief during a visit to a rainforest conservation project in Iwokrama, Guyana.

Wearing a safari jacket, white trousers and white desert boots, Charles enthusiastically held hands with indigenous women and danced after the ceremony.

His visit to the million-acre region of South America had a serious point. He was at the four-year-old rainforest project to learn about the impact of deforestation on the world's environment.

He said: "The rainforests are the world's thermostat; they sustain the lives of some of the poorest people on earth and yet deforestation continues."

The Prince suggested wealthy countries should help pay credit to nations like Guyana to retain their rainforests.

Later in 2002, Camilla was publicly re-introduced into the Queen's circle. Here she sits in the royal box at Proms At The Palace.

QUEEN ACCEPTS CAMILLA

JUNE 3, 2000

The Queen and Camilla Parker Bowles joined in an historic show of unity before the crowned heads of Europe.

It was the first time they had met in public since her affair with Charles began. It meant the Prince and Camilla were free to marry if they wished.

"It was very special," said a family friend. "Camilla and Charles are overjoyed about their future."

The Queen and Camilla held a private heart-to-heart about her position at Charles's side.

It took place at an open-air barbecue by the biggest gathering of European royalty since Prince Andrew's wedding to Fergie in 1986.

A friend said: "No one is saying marriage is an immediate probability, but it is much easier to talk about it than 24 hours ago.

"Charles is aware there will be intense speculation about their plans."

The party at Charles's Gloucestershire country home, Highgrove, was a 60th birthday barbecue for ex-King Constantine of Greece.

The Queen was wearing a blue dress and a diamond brooch. Camilla was dressed in a casual cream linen dress and jacket. Her Majesty walked over to Charles's love in the drawing room and Camilla did a huge formal curtsey. They chatted for ten minutes.

Fellow guests included King Juan Carlos of Spain, Queen Margarethe of Denmark and King Harald of Norway.

HIYA CHUCK

DECEMBER 8, 2000

Prince Charles shared a chuckle with Vera Duckworth on a historic tour of Coronation Street.

He went on the day a live episode was broadcast to mark the soap's 40th anniversary. Vera, who thought she had royal blood, was in hospital after donating a kidney.

Actress Liz Dawn joked: "Have you brought me any grapes?"

Charles also got an invitation to run away with Liz McDonald.

As he sipped a scotch in the Rovers Return, Charles asked actress Beverley Callard about her character Liz.

Then taking the 52-year-old Prince by both arms she made her bid to be "Queen Liz".

Bev, 43, joked: "There's always room for an older man."

Charles toured the Corrie set and he agreed for news footage of his trip to Weatherfield to be shown in the live episode being aired that night, the first live episode since 1961.

Technically appearing as himself, Charles received a credit for his brief cameo.

The Prince also met 68-year-old actor Bill Roache, whose character Ken Barlow was the last one remaining from the original show.

Bill said: "We couldn't have a better way to celebrate 40 years. We're thrilled to bits."

Charles watched rehearsals and assured the cast he and Corrie fan Camilla would be tuning in for the live episode.

He said: "Coronation Street is a wonderful institution."

Charles was the first member of the Royal Family to stroll along Coronation Street since the Queen met Hilda Ogden in May 1982.

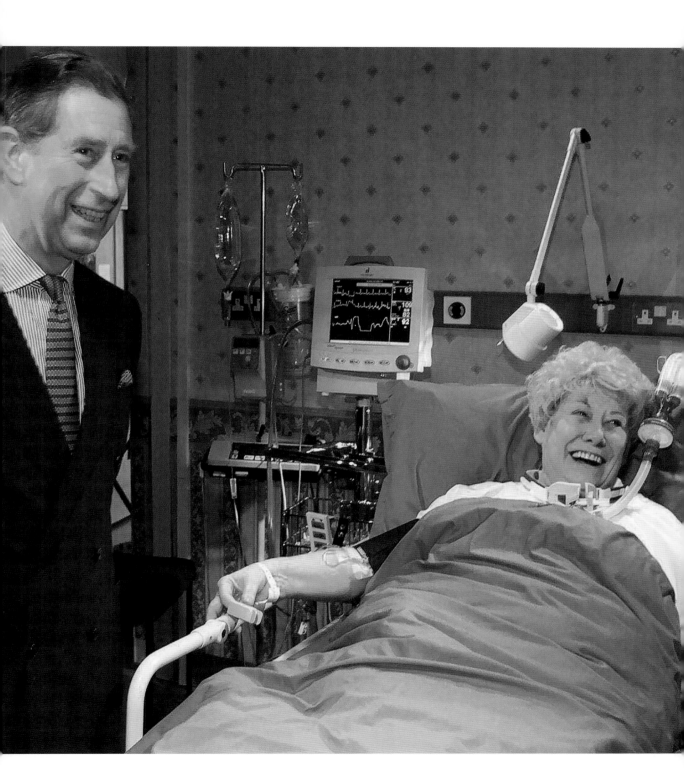

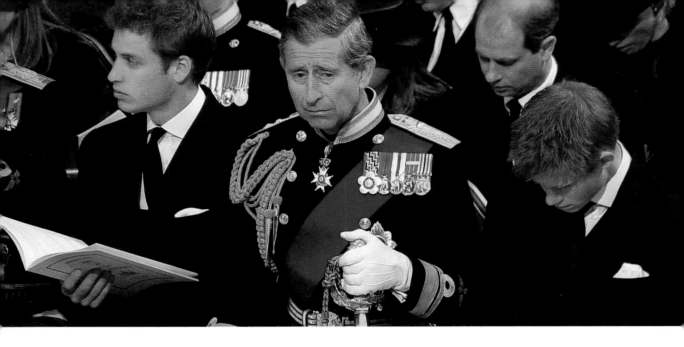

MAGICAL GRANDMOTHER

MARCH 30, 2002

Tearful Prince Charles wrapped comforting arms around sons William and Harry as they said an emotional farewell to the Queen Mother.

The three Princes spent 20 minutes by her coffin after cutting short their skiing holiday in Switzerland to jet back to Britain.

They were driven from RAF Northolt to The Lodge, the Queen Mother's home on the Windsor Estate. She died there aged 101.

Charles was particularly close to the Queen Mother. He described her as a "magical" grandmother who understood the British people.

On the family's annual summer trip to Scotland in 1992, she had been unable to shake off a persistent cold and became dangerously frail.

Charles was so concerned about her health he moved out of Balmoral and into her home Birkhall so that he could take care of her.

In October 2001 he had taken her on a surprise day out to help him unveil a statue of a bull in the town of Alford, Aberdeenshire.

The 101-year-old delighted the crowd.

She had not been scheduled to attend the event to recognise the town's historic links with the Aberdeen Angus breed. The pair chuckled throughout the ceremony.

Charles said: "What a marvellous occasion this is, particularly that Her Majesty, my grandmother, has been able to come on this special day."

His devotion was not surprising. Throughout his life he often relied on her more than his mother. Royal tours forced the Queen to leave her toddler son with his granny. She treated him like the son she never had.

As one courtier explained: "She saw in Charles many of the qualities her husband, King George, had – his diffidence and his soft heart."

Bullied at Gordonstoun, he begged his grandmother to let him leave its harsh regime. Three decades later Princes William and Harry developed a similar special devotion to their great-grandmother.

The break-up of three royal marriages was to her a family tragedy, but she refused to dwell on unhappiness. She told her grandchildren that better days lay ahead.

Her cheerful example was her greatest legacy to them all.

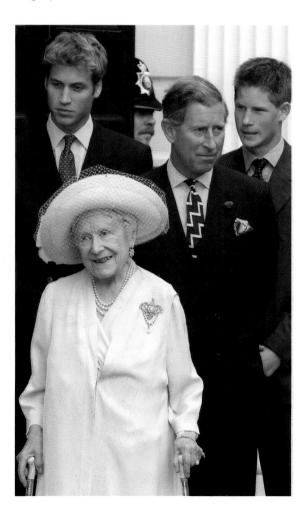

The Queen Mother was one of Charles's favourite people in the world.

LADY IN WED

FEBRUARY 10, 2005

Prince Charles posed with his lady in red after they announced they would marry.

Charles and a beaming Camilla were pictured at a Windsor Castle charity gala.

They were greeted by cheers and applause. And radiant Camilla – proudly revealing her diamond and platinum engagement ring – said she was "just coming down to earth" after the excitement of the engagement.

Smiling Charles told well-wishers: "I am very happy."

Asked if her fiancé proposed on bended knee Camilla said with a wide grin: "Of course, what else?"

The couple were at a dinner for the Prince of Wales' Business and Environment Programme, one of his charities.

Earlier it emerged Camilla had turned down the title Princess of Wales to avoid a backlash from fans of Charles's late wife, Princess Diana. Camilla chose Duchess of Cornwall instead.

Divorced Camilla kept her new title, which stemmed from Charles's position as head of the Duchy of Cornwall until he was crowned King.

One senior aide said: "She knows she cannot follow Princess Diana and has no intention of doing so."

Camilla's engagement ring was a Royal Family heirloom, once worn by the Queen Mother. It features a five-carat emerald-cut diamond in the centre with diamond baguettes either side.

Her bold scarlet dress was by designer Jean Muir.

Charles was believed to have proposed during their Christmas break at Birkhall, Scotland.

He told Princes William and Harry at Sandringham and both were said to have given their blessing.

In a statement from Clarence House, Charles said: "Mrs Parker Bowles and I are absolutely delighted. It will be a very special day for us and our families."

The Queen and Duke of Edinburgh sent their "warmest good wishes for their future together."

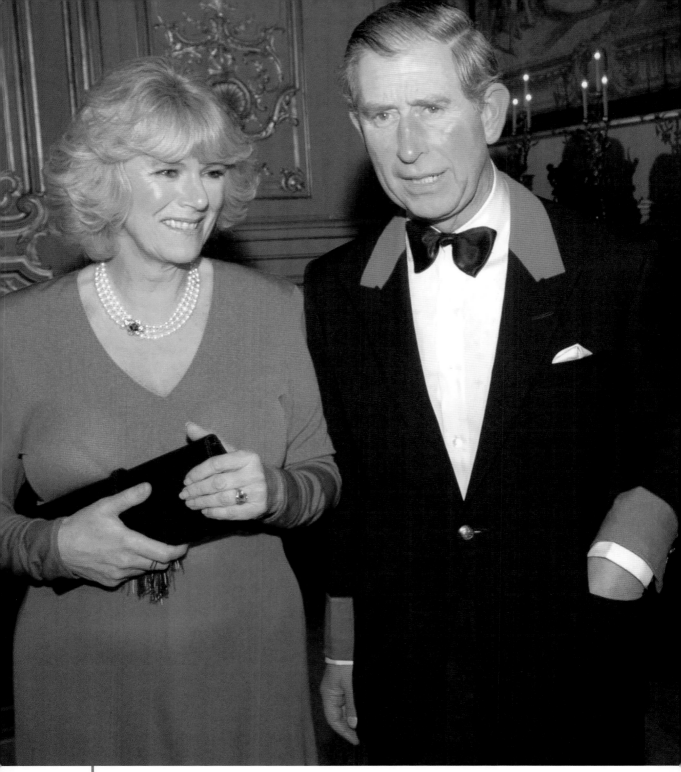

Charles and Camilla attend a charity ball while sharing news of their engagement.

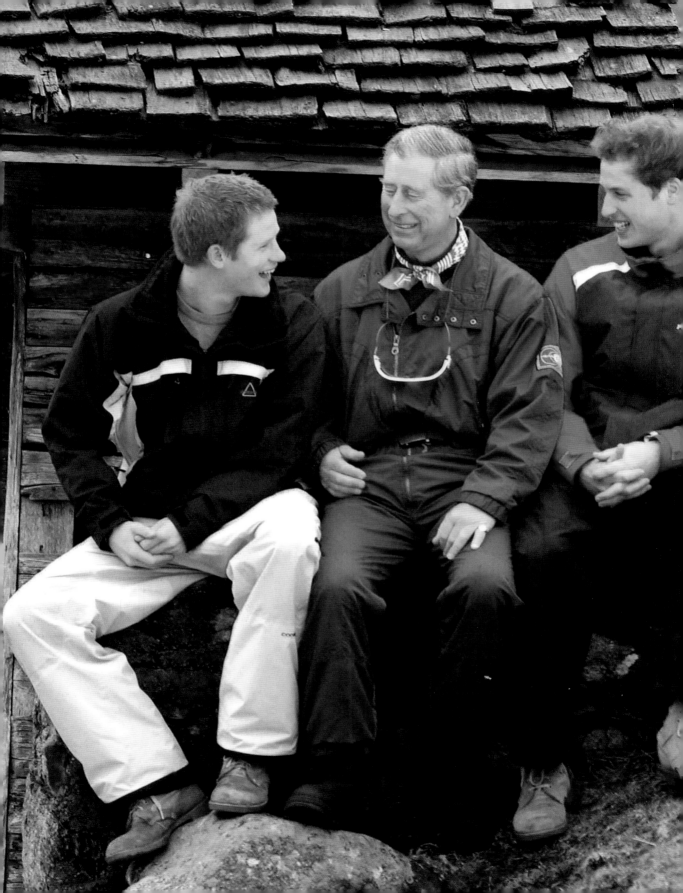

THAT AWFUL MAN

MARCH 31, 2005

The full extent of Prince Charles's frustration with the media was exposed on a ski slope.

A pre-wedding photocall with sons William and Harry turned into a public relations nightmare when microphones picked up the Prince muttering "bloody people" about reporters.

The BBC's royal correspondent Nicholas Witchell was singled out. Charles told his boys: "I can't bear that man. He's so awful, he really is."

Further complaints were picked up by tape recorders: "I hate doing this" and "I hate these people."

Fifty journalists had been invited by Clarence House to Klosters, Switzerland, where the family was skiing with friends.

The Prince was asked by Witchell – who had 30 years' experience as a reporter – for his thoughts on his forthcoming marriage to Camilla Parker Bowles.

He replied: "Very happy. It'll be a good day."

Clarence House communications secretary Paddy Harverson – who used to work for that other wallflower, Sir Alex Ferguson – said the Prince regretted the comments.

He said: "He wasn't looking forward to it. He prefers it when he skis."

The photo opportunity happened every year for all of five minutes. Prince William happily gave an interview to *The Sun* that morning to stress he WASN'T getting married any time soon.

Charles and his sons enjoy a joke at the expense of the press.

121

MEET THE MISSUS

APRIL 9, 2005

It had taken 34 years and decades of hope and heartache but finally Prince Charles and Camilla Parker Bowles could call each other husband and wife.

The Prince of Wales' marriage to the woman he had met in a flat near Victoria Bus Station was blessed at St George's Chapel, Windsor Castle. Together they would one day become King and Queen.

The register office wedding took place in the Guildhall, Windsor, with crowds outside – but two notable guests were missing.

The Queen, as head of the Church of England, chose not to attend the marriage of two divorcees. Prince Philip stayed away too, understanding his wife's duties outweighed her familial obligations.

They did both attend the blessing at St George's Chapel later in the day and posed happily for the official wedding pictures.

For the Guildhall, Camilla looked stylish and happy in a plain cream silk dress and matching coat with wide-brimmed Philip Treacy hat.

For the blessing she changed into a pale blue-grey chiffon gown with matching coat embellished with gold embroidery, complemented with a chic gold feathered headdress also by Philip Treacy.

The Queen blessed the couple with her wit. Opening her speech at the wedding party she said she had two announcements. The first was that Hedgehunter had won the Grand National; the second was that, at Windsor, she was delighted to be welcoming her son and his bride to the 'winners' enclosure.

"They have overcome Becher's Brook and The Chair and all kinds of other terrible obstacles. They have come through and I'm very proud and wish them well. My son is home and dry with the woman he loves."

Finally, a fairytale ending for the Prince and his bride.

GRIEF AT GROUND ZERO

NOVEMBER 1, 2005

Camilla showed her grief for the victims of 9/11 with an emotional visit to Ground Zero.

The Duchess of Cornwall placed a bouquet at the memorial overlooking the spot where 2,753 people died in the Twin Towers terror attack.

She and husband Prince Charles went straight there after touching down at the start of their eight-day tour of the United States.

They paused for reflection before Camilla laid the yellow and orange orchids, roses, lilies and hydrangeas.

With them she placed a card, handwritten by the Prince, reading: "In enduring memory of our shared grief," and signed by both of them.

The royal pair spent several minutes chatting to New York Governor George Pataki as they gazed over barriers into the deep pit.

They also visited the Family Room, an area set aside for relatives of the dead.

The walls were plastered with personal heart-wrenching mementos, photos and birthday cards.

Charles and Camilla were then whisked to the British Memorial Garden less than a mile from Ground Zero.

Charles said to families who came to see them there: "My wife and I are profoundly moved by what we saw, not just the scale of the outrage but the deeply distressing individual stories of heroism and loss. Our hearts go out to you."

The couple faced their toughest test yet in their bid to woo America – a country that adored Princess Diana.

It was their first foreign trip together and the first time Charles had made an official visit there since 1994.

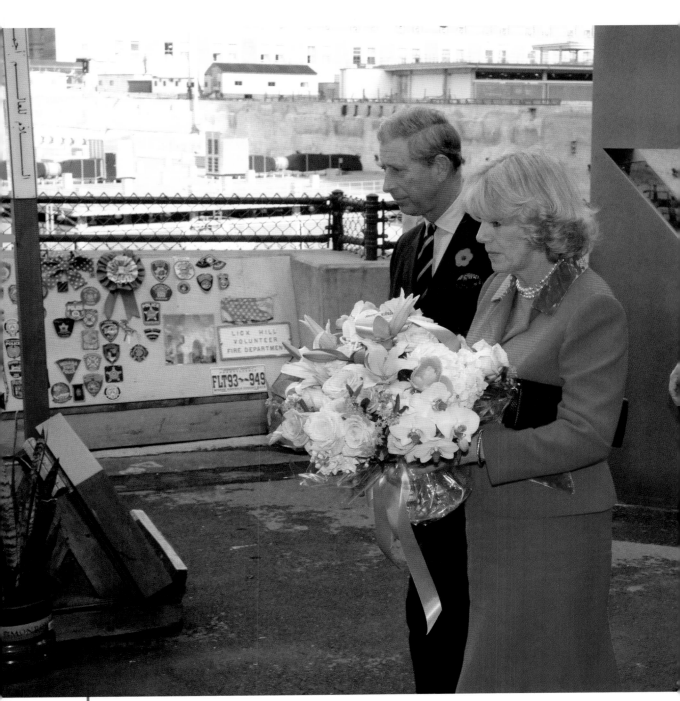

Camilla and Charles pay tribute to the victims of 9/11 at Ground Zero.

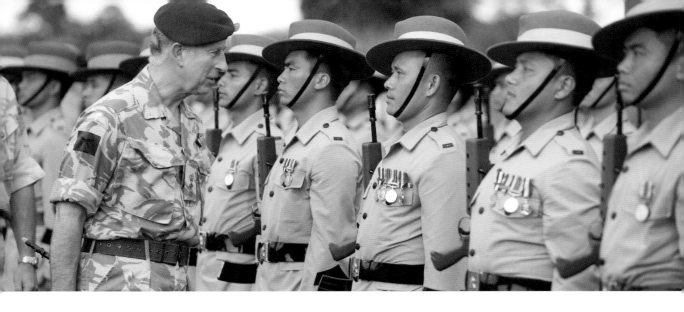

GURKHY HARRY

OCTOBER 31, 2008

Proud Charles paid a special visit to Gurkhas stationed in Brunei while on a visit to the sultanate with wife Camilla. The Gurkhas paid tribute to Prince Harry's courage while working with the soldiers.

Harry's heroism battling the Taliban was revealed for the first time as it emerged he was made an honorary Gurkha while serving with the fearsome troops.

He earned the respect of the crack Nepalese warriors as he spent six of his ten weeks on the frontline in Afghanistan bravely fighting alongside them.

His comrades in lawless Helmand province – armed with their terrifying Kukri knives and famed for their killing skills – were so impressed they made him one of their own.

And to prove it they awarded the Household Cavalry lieutenant the greatest tribute they could bestow – one of their lethal daggers.

Charles, who is Colonel in Chief of the Gurkhas, told Lance Corporal Bhim Garbuja: "I am so proud that my son was able to serve with the Gurkhas."

Captain Surya Gurung revealed: "Harry was so liked by the soldiers. He is a good officer, and he earned their respect in the field of battle.

"Before he left, the men presented him with the Kukri. It is our prized weapon, and we don't usually hand them out.

"As far as we are concerned, he should consider himself an honorary Gurkha now."

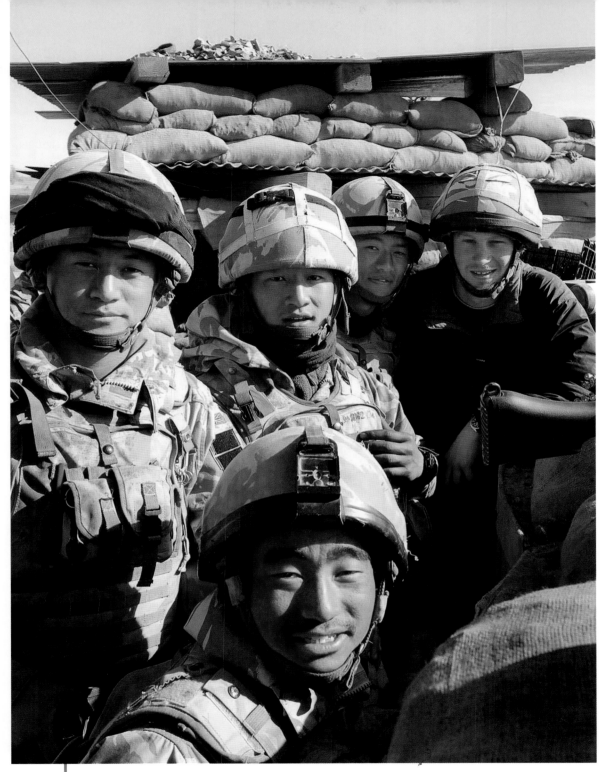

Charles in Brunei and Prince Harry in Helmand province.

OFFICIAL: HE'S WORLD'S BEST DRESSED MAN

MARCH 4, 2009

Prince Charles was named 'Best Dressed Man In The World' by Esquire magazine.

The heir to the throne flew the flag for British fashion by beating Barack Obama, rapper Andre 3000, and tennis legend Roger Federer to the title.

Esquire Fashion Editor Jeremy Langmead said: "It's the men who dress as grown-ups who really caught the judge's eye."

The Prince regularly donned Savile Row double-breasted suits, accessorised with silk ties and handkerchiefs. He stuck to classic English tailors like Anderson and Sheppard and Gieves and Hawkes.

His shoes were from Crockett & Jones and Lobb. His shirts from Turnbull & Asser and his outerwear from Burberry and Barbour.

Style journalist Simon Mills said: "Charles believes in supreme quality, beautifully handcrafted investment pieces.

"As the most powerful brand ambassador for Great British menswear, Prince Charles should be kept steamed, sponged, polished and wrapped in tissue paper – and aired in public as regularly as possible."

The Prince of Wales came from a long line of male royal clothes horses. His great uncle, the Duke of Windsor, loved colour and started trends that were picked up by dapper men across the world.

Jeremy Hackett of gentlemen's outfitters Hackett said: "The brilliant thing about Prince Charles is the way he never follows trends, but still manages to look so stylish."

Charles said of his fashion sense: "I have lurched from being the best-dressed man to being the worst-dressed man. Meanwhile, I have gone on – like a stopped clock – and my time comes around every 25 years."

A few of Prince Charles's most famous looks.

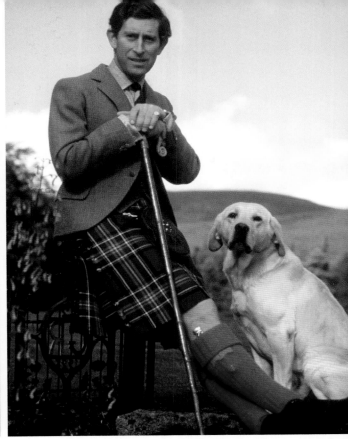
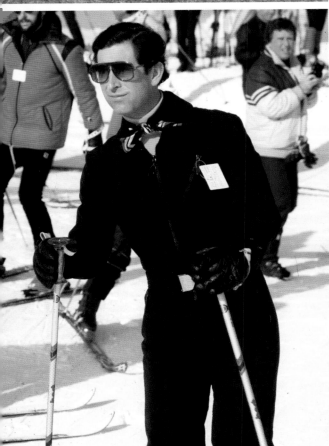

CHARLES BRAVES TALIBAN DEATH ZONE

MARCH 25, 2010

Prince Charles flew into the heart of Taliban territory to visit our brave front line troops.

The 61-year-old donned combat fatigues, helmet and body armour for the surprise visit to Helmand province.

He insisted on going "outside the wire" to a Forward Operating Base on his first visit to Afghanistan.

Despite the risks of being shot, he climbed on a Chinook helicopter for the eight-minute flight from Camp Bastion to FOB Pimon in Nad-e-Ali district.

Clarence House confirmed he was the "only royal in living memory" to visit Kabul. He met soldiers taking part in Operation Moshtarak – a bid to smash the last Taliban strongholds.

The Prince went beyond the parts usually visited by VIPs and a senior Clarence House source said: "The Prince wanted to see for himself the areas where troops are making so many sacrifices."

Charles flew into Afghanistan under cover of darkness. He spent the night at Camp Bastion – and bore a strong resemblance to Prince Harry who was there in 2008.

As he visited a war memorial at the base, Charles said: "It's a very worrying time for families, when my youngest son was out here, as a parent you worry the whole time.

"It makes me incredibly proud of what they do."

It was a mission which generated phenomenal security, but Charles said he simply wanted to come to say thank you to the troops.

The Prince of Wales listens to a British soldier at British military camp Pimon in Nad-e Ali district of Helmand province.

HARRY GIVEN HIS WINGS

MAY 7, 2010

Prince Harry was awarded his provisional pilot wings by his proud father – who also happened to be his Colonel in Chief.

Top brass were so impressed with young Lieutenant Harry Wales, as he was known in the Army, they selected him to train as an Apache attack helicopter pilot with a possible return to the front line of Afghanistan.

In his military role Prince Charles inspected his son and eight other pilots from the Army Air Corps and presented them with their wings.

The ceremony at the Army Aviation Centre in Middle Wallop, Gloucestershire, marked the 25-year-old Prince's graduation from an advanced helicopter training course.

Charles remarked to his son: "You are looking very smart if I may say so."

The young Prince's girlfriend Chelsy Davy and his aunts, Lady Jane Fellowes and Lady Sarah McCorquodale – Princess Diana's sister – watched the ceremony.

Harry swapped hats to signify his move from the Household Cavalry Regiment to the AAC.

He was awarded a trophy for the best tactical ability during his operational training.

Harry said: "It is a huge honour to have the chance to train on the Apache, which is an awesome helicopter. There is still a huge mountain for me to climb if I am to pass the Apache training course. I am very determined though as I do not want to let down people who have shown faith in my ability to fly this aircraft on operations. It is a seriously daunting prospect, but I can't wait."

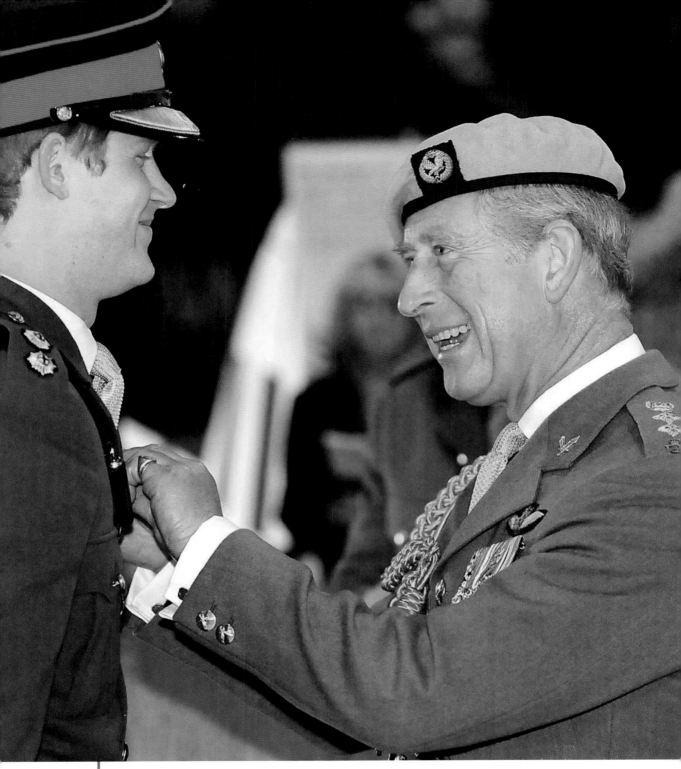

Charles proudly pins Harry's pilot wings to his chest.

SOMETHING BORROWED, SOMETHING BLUE

APRIL 29, 2011

Prince Charles's £350,000, 41-year-old, open-topped Aston Martin stole *some* of the show as Prince William and Kate Middleton wed.

Amongst the pomp and solemn ceremony; and the romance of the balcony kiss; fun-loving Prince Harry engineered a classic comedy moment.

Using his dad's much-loved car, Harry arranged for the bride and groom to drive off with party balloons and a JU5T WED number plate.

The time-honoured best man's prank delighted the thousands waiting outside

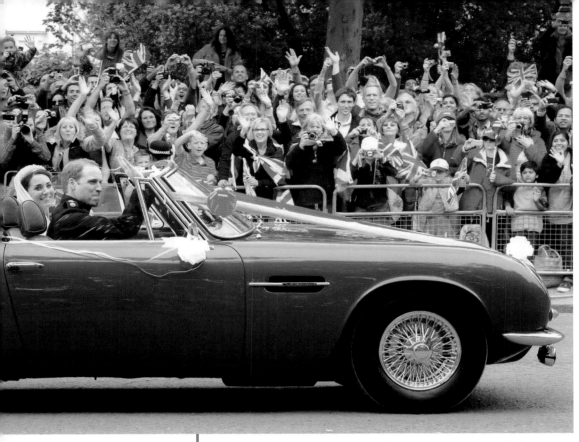

Classic memories. Charles's beloved DB6 now runs on eco-fuel made from wine and cheese.

Buckingham Palace – and had millions more watching on TV in giggles.

Wills and Kate grinned broadly as they slowly drove the 500 yards down The Mall to Clarence House – to the deafening accompaniment of laughter, cheers and clapping from the vast crowd.

Although the car was old, the gesture was wonderfully modern, encapsulating a day that started with choirs at Westminster Abbey and ended with pop music.

Charles bought the blue Aston Martin DB6 Volante when he was a student at Cambridge University. It became a common sight at polo grounds around the countryside as the bachelor Prince would turn up for matches with the roof down.

Many of his girlfriends including Davina Sheffield, Sabrina Guinness, Lady Sarah Spencer and her sister Lady Diana were seen in the passenger seat through the 1970s and 80s.

For Kate and Wills' wedding, the vintage motor symbolised a loving and committed royal couple.

CHARLES AT THE POUND SHOP

25 NOVEMBER, 2011

The Prince of Wales's model village in Dorset was given an economic boost when the Royal opened a Waitrose store in the development.

The new upmarket supermarket created 43 jobs for local people at a time when the country was experiencing economic downturn.

Charles toured the outlet in Queen Mother Square in Poundbury and was greeted on his arrival by hundreds of residents and a brass band.

The food retailer sells the Duchy Originals at Waitrose range which was founded by Charles in 1990, and later became a joint venture with the food retailer.

He chatted with Andy King, a Somerset dairy farmer, who had been supplying organic milk to the Duchy brand for ten years.

Andy said: "He really does have an understanding of farming and what we are trying to do – trying to build a sustainable business over the long term.

"He understands the difficulties we are facing in the industry – but thank goodness things are picking up."

Duchy Originals was thrown a financial lifeline in 2009 when Waitrose announced a multi-million-pound investment deal, in return for the exclusive right to manufacture, distribute and sell its products.

Through the Prince of Wales's Charities Foundation, Duchy Originals supports a wide variety of projects ranging from the environment to arts and education.

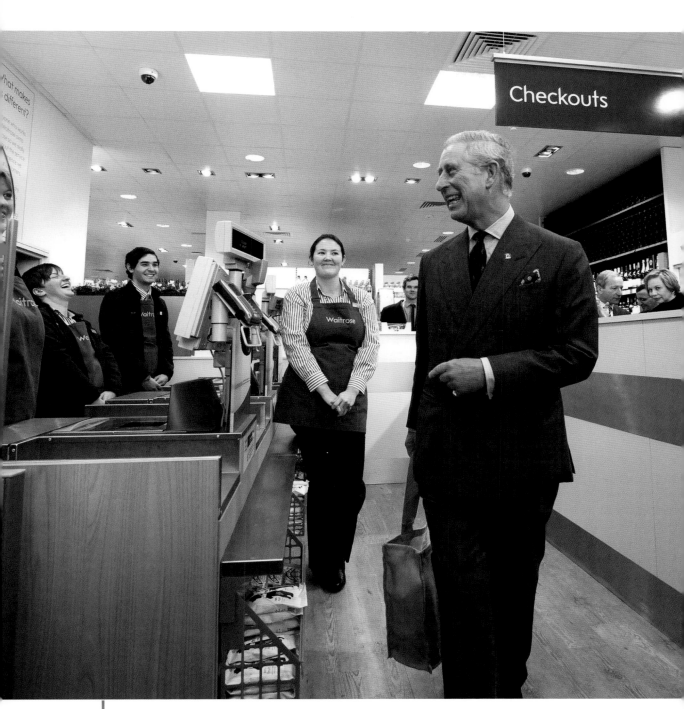

Charles jokes with Waitrose staff in Poundbury.

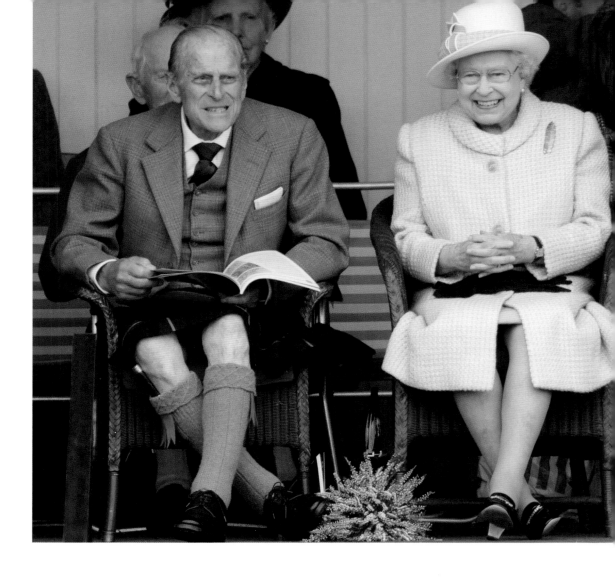

KILTY PLEASURES

SEPTEMBER 1, 2012

A relieved Prince Charles enjoyed the Braemar Gathering following his father's health scare.

Plucky Prince Philip showed high spirits as he shared a joke with the Queen and Charles at Scotland's oldest Highland Games. The 91-year-old Duke seemed almost back to his jovial best.

Of course, Philip and Charles – known as the Duke of Rothesay in Scotland –

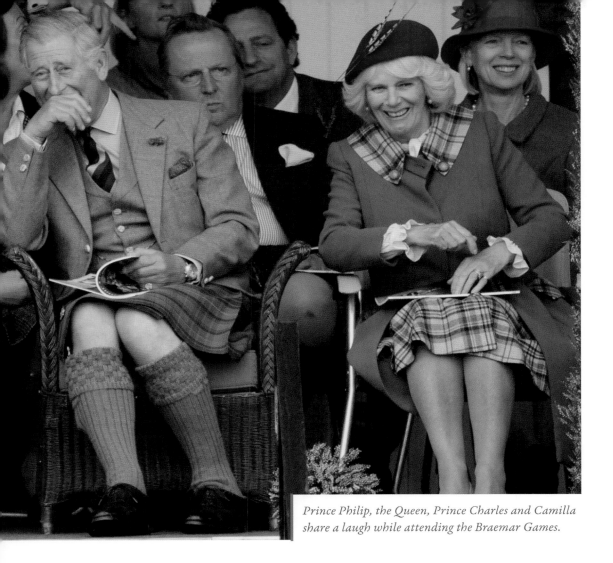

Prince Philip, the Queen, Prince Charles and Camilla share a laugh while attending the Braemar Games.

donned kilts for the event, which is one of the Royal Family's favourite events of the year.

An onlooker said: "It was great to see Prince Philip smiling. He seemed to be enjoying himself, it was wonderful he could attend."

The Royal party, which included the Duchess of Cornwall, were staying at the Balmoral estate.

There have been Gatherings of one sort or another at Braemar since the days of King Malcolm Canmore nine hundred years ago.

The celebration of Scottish sport and culture is held annually on the first Saturday of September.

Charles painting while on the ski slopes of Klosters, Switzerland.

CHARLES IS AN EXHIBITIONIST

APRIL 19, 2013

Prince Charles put 130 of his watercolour paintings on display in an online exhibition called Life In Pictures.

The collection was the largest selection of his work ever seen in public.

Charles's paintings reflect his love of the countryside and the environment with landscapes from the Balmoral, Sandringham and Highgrove Estates as well as many of the places he has visited around the world.

Charles is such a keen artist, he had a watercolour displayed in the Royal Academy's 1987 summer exhibition, after it was submitted anonymously.

The Prince curated the exhibition himself, they feature the copyright mark A.G. Carrick. "A.G." comes from his middle names Arthur George and "Carrick" comes from his title Earl of Carrick.

Clarence House said: "The Prince has been an enthusiastic amateur artist and keen collector and Patron of the Arts for many years.

"The Prince likes to paint whenever his schedule allows – whether on private holidays, or during a spare moment on an overseas tour – and finds it a most absorbing occupation.

"These watercolours provide an insight not only into the Prince's artistic interpretation of his environment, but into his private and public life."

In 2000, the Prince of Wales founded the Royal Drawing School in London, an independent educational charity offering public courses taught by contemporary practising artists.

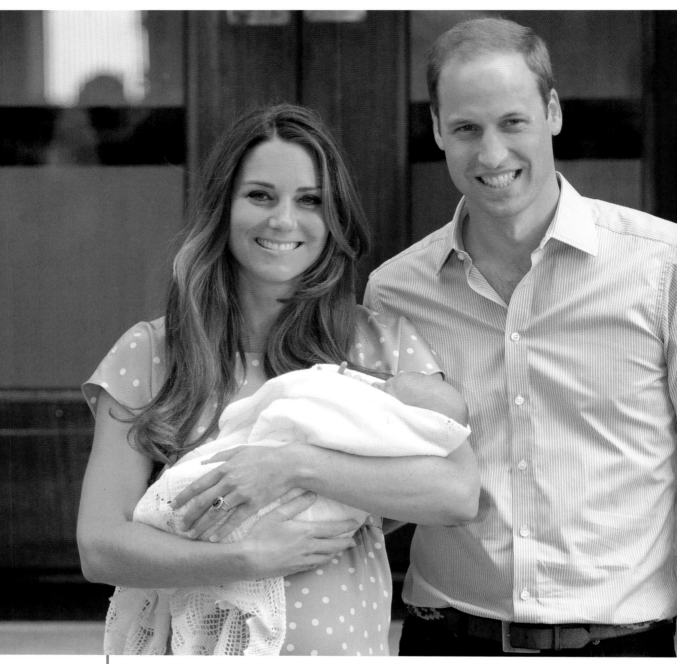

Prince William and Catherine Duchess of Cambridge leaving
St Mary's Hospital with newborn son Prince George.

THE REGAL HAS LANDED

JULY 21, 2013

The world welcomed a future King as the royal baby was finally born – an 8lb 6oz boy.

Prince William was at wife Kate's side as the tiny Prince was delivered.

Wills beamed: "We could not be happier."

His son arrived at 4.24pm – but the birth of the third in line to the throne was then kept a closely guarded secret for more than four hours while the official announcement was prepared.

When the news finally broke it sent crowds who had flocked to St Mary's Hospital in London's Paddington – and to Buckingham Palace – into raptures.

From among the thousands at the palace gates came sudden excited shouts of "Boy!" Spontaneous applause erupted – and another cry went up: "Three cheers for Kate!"

The exhausted new mum deserved it after a gruelling 11-hour labour.

Royal tradition dictated the first to be informed was the Queen – who got an excited phone call from the new parents.

Next to get a ring was Prince Charles who became a grandad for the first time.

He described himself and wife Camilla as "overjoyed". Charles said: "It is an incredibly special moment for William and Catherine and we are so thrilled for them on the birth of their baby boy.

"Grandparenthood is a unique moment in anyone's life, as countless kind people have told me in recent months. So I am enormously proud and happy to be a grandfather for the first time. We are eagerly looking forward to seeing the baby in the near future."

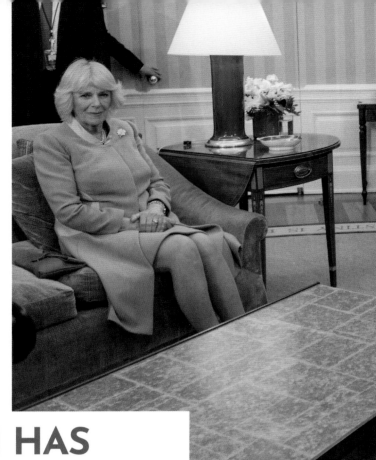

The Prince of Wales and Duchess of Cornwall met President Obama and Vice President Biden at the White House.

THIS MAN HAS BEEN FOLLOWING ME FOR 37 YEARS

MARCH 19, 2015

Camilla and Prince Charles had a laugh with Royal snapper Arthur Edwards in the White House.

They were guests of President Obama, who was impressed by *Sun* photographer Arthur's loyalty to the couple.

During a photo to mark their meeting, Charles pointed at Arthur and said: "This man has been following me for, how long?"

Arthur replied: "Thirty-seven years, sir."

Smiling President Obama said: "That's awesome."

As the pair posed for the cameras Mr Obama said: "I think it's fair to say that the American people are quite fond of the

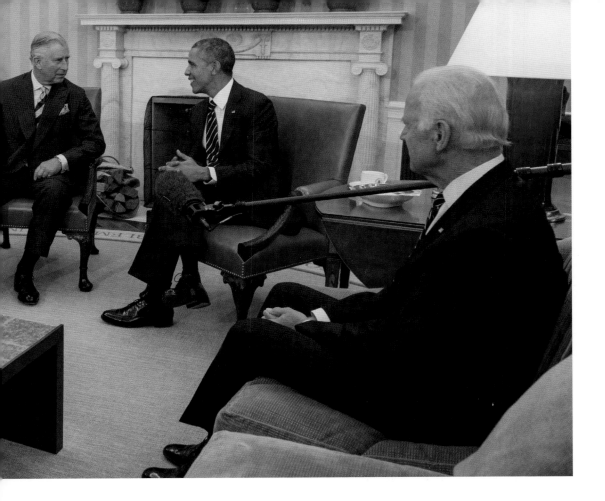

Royal Family. They like them much better than they like their own politicians."

The Prince of Wales rebutted: "I don't believe that."

The President said how fondly Americans had watched Prince William and Kate Middleton's wedding and how well the couple had dealt with the pressure of their big day.

Vice President Joe Biden also participated in the Oval Office meeting.

Charles and his wife had arrived in the U.S. the day before. On a tour of the National Archives, Washington, Charles was genuinely surprised and delighted to learn something new about his family.

Archivist David Ferriero presented the Prince with a patent application submitted in 1931 by his uncle, Lord Louis Mountbatten, for a new kind of polo stick.

Charles, himself a polo player, laughed and said he had no idea that his uncle had designed such a thing.

THE GRANDFATHER I NEVER HAD

MAY 20, 2015

Prince Charles finally bade goodbye to his great-uncle at the spot where he was murdered by the IRA 36 years previously.

He said his life was "torn apart" after the "grandfather I never had" was bombed in 1979.

He paused and gazed out to sea as he arrived at Mullaghmore Harbour, County Sligo, where Lord Louis Mountbatten's fishing boat had set off. Just minutes into the voyage, a 50lb bomb detonated, killing four.

With wife Camilla, Charles led a slow march into the village's Peace Garden. He was followed by Lord Mountbatten's grandson Timothy Knatchbull, who was injured in the blast in which twin brother Nicholas, 14, died.

The Prince met rescuers who tried to save the lives of those on board Shadow V, as well as other relatives of the dead.

Charles said earlier: "I could not imagine how we would come to terms with the anguish of such a deep loss since, for me, Lord Mountbatten represented the grandfather I never had.

"So, it seemed as if the foundations of all that we held dear in life had been torn apart irreparably."

But he went on: "I now understand in a profound way the agonies borne by so many others in these islands, of whatever faith, denomination or political tradition."

He also issued a rallying cry for peace – insisting Britain and Ireland could no longer be "victims of our difficult history with each other".

Bidding farewell (top) and talking to Lord Mountbatten with Prince Philip at Tidworth Polo Club in July 1978.

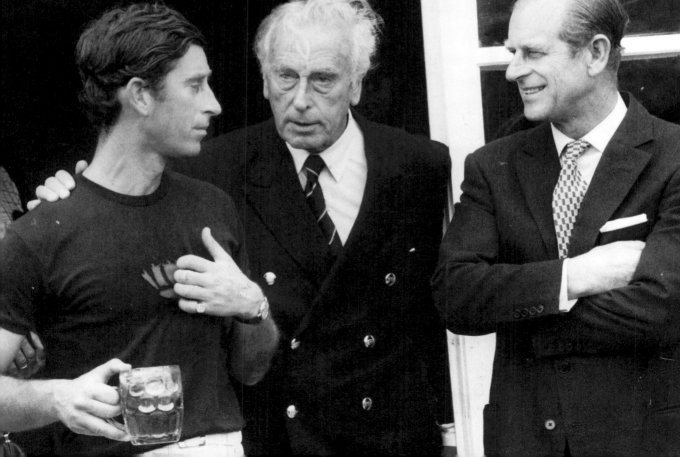

WHEN ANT AND DEC MET WILLS AND HARRY

JANUARY 6, 2016

Ant McPartlin risked flashing his crown jewels at Prince Charles during a royal sleepover – as he hadn't brought any pyjamas.

Ant and telly sidekick Declan Donnelly spent the night at one of the future King's Scottish residences, Dumfries House, as part of their documentary celebrating 40 years of The Prince's Trust charity.

The ITV show looked at the phenomenal success of the Trust and what motivates Charles to keep striving to help young people.

Interviewed at Kensington Palace by the TV funsters, also ambassadors for the charity, Charles's son Prince William said proudly: "He has an insurmountable amount of duty. It's where his passion and drive comes from.

"He relishes the challenge but has had such a difficult time trying to get across some of his issues, it's a real credit to keep fighting as much as he has."

Prince Harry added: "The advice he can give us based on the contacts he's made over the years is incredible."

At Charles's Welsh home, Llwynywermod, Camilla told the Britain's Got Talent hosts: "I am really proud to be married to someone who 40 years ago, aged 27, had the vision to put it together. It was an incredible idea.

"To think of these very disadvantaged people who had been to hell and back and to give them a second chance at life."

Asked by Dec how her husband had maintained his energy and enthusiasm for the Trust, she said: "He cares so much about these young people."

At a prison session teaching football coaching to young offenders, Charles said: "I was always terribly keen we should do as much as possible to reach those who are hardest to reach. A lot of people end up in prison because they haven't had the attention hopefully we can pay to people."

About the future of his charity, the Prince said: "You can't sit back and think you've done a marvellous job; you need to constantly be thinking of new issues in order to stay relevant."

The Prince's Trust returned £1.4 billion in benefits to society through its help for disadvantaged young people between 2006 and 2016 alone.

HEIR MAIL

APRIL 21, 2016

Little Prince George wore a beaming smile when he posed for a postage stamp to mark the Queen's 90th birthday.

The two-year-old scamp grinned alongside dad William, grandpa Charles and great-grandmother the Queen for the iconic four generations picture.

But he had to stand on foam blocks to ensure his head was on the same level as the other royals.

George held his father's hand for the photo – taken in Buckingham Palace's white drawing room in June 2015.

The young Prince's first stamp was part of a set of ten celebrating the Queen's

First class scamp. The Queen poses for a picture to be used on a stamp with her three heirs.

90th birthday, which also included six images of Her Majesty.

The family photo was used to create a stamp sheet, with perforations carefully positioned to create a first-class stamp for each of the four royals.

Photographer Ranald Mackechnie said:

"Prince George was in good form, very happy and fascinated by the lights and my kit.

"I wanted a warm family portrait and hopefully we got what we wanted. It was an amazingly relaxing and light-hearted sitting."

I'M HAVANA TRIM

MARCH 25, 2018

Prince Charles got in trim on the first official royal visit to Cuba – at the barber. The 70-year-old heir to the throne turned down owner Josephine Nandes' offer of a short back and sides at the salon in Havana.

He and the Duchess of Cornwall were mobbed during their walkabout in the Cuban capital as it celebrated its 500th anniversary.

During the tour, the couple saw a plaque in their honour and unveiled a statue of William Shakespeare.

Charles went to a wreath-laying ceremony at the memorial for Cuban independence hero José Marti – overlooked by a mural of revolutionary Che Guevara.

The Prince also pressed the flesh while crushing sugar cane. He helped to make syrup used in a mojito cocktail, downed by wife Camilla, during a visit to a paladar, or private restaurant. Before the trip, Camilla had said she was not sure about Cuban food. The event was set up following her comments.

Nibbling on goat's cheese, she said: "I've never had cheese with ginger – very good."

The Duchess later promised to send her food writer son Tom Parker Bowles to Cuba to write about the cuisine.

As Charles and Camilla left the restaurant, the Prince said to Lis Cuesta Peraza, the wife of Cuba's President who had joined them: "Will you give my fondest regards to your husband, and say how grateful we are for his generosity and hospitality? We will never forget it."

They were the first royals to visit the Caribbean island since Cuba's communist revolution in the 1950s.

Charles and Camilla bring a light touch and genuine interest to diplomatic visits on behalf of the Crown.

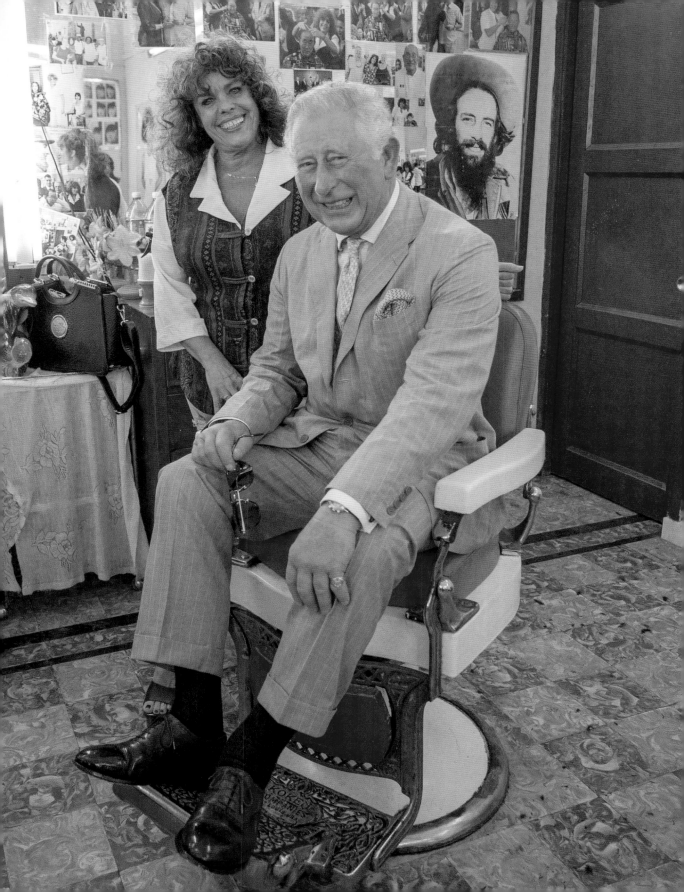

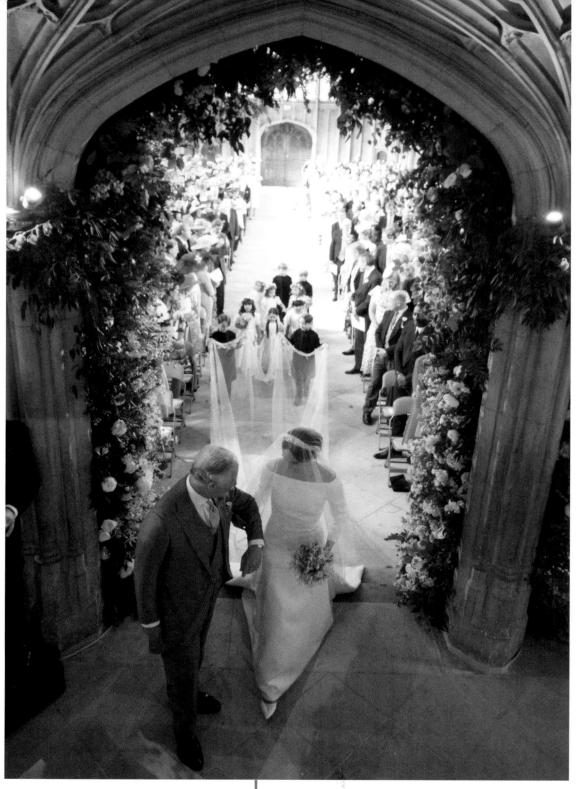

In place of her absent father, Charles accompanies Meghan Markle at her wedding to his son Harry.

PROUD CHARLES WALKS MEGHAN UP THE AISLE

MAY 19, 2018

Prince Charles stood in for absent father Thomas Markle when he accompanied Meghan on her wedding day.

Meghan, in a simple and elegant Givenchy gown, walked alone halfway down the aisle at St George's Chapel in Windsor Castle.

She then took her father-in-law's hand to walk towards Harry, who appeared close to tears as he waited anxiously with his brother Prince William. Harry, who had nervously fiddled with his cuffs while waiting, turned to Charles and said: "Thank you, Pa."

Harry gazed at American actress Meghan and said: "You look amazing... absolutely gorgeous."

The Suits star said, "Thank you" and asked, "Are you OK?" Harry grinned and replied: "Absolutely."

And in an apparent reference to them spending just one night apart at separate hotels, he laughingly said: "I missed you." The couple took their vows and answered strongly: "I will."

Harry went first, stroking Meghan's finger when he slipped on a Welsh gold ring.

As his bride made her vows, her watching mother Doria nodded in agreement.

Meghan slipped a platinum band on Harry's finger and Archbishop of Canterbury, the Most Rev and Rt Hon Justin Welby pronounced them husband and wife.

The couple – who were given the title The Duke and Duchess of Sussex by the Queen – sealed their union with a kiss.

As they climbed into their carriage, they were waved off by a bridal party that included Harry's nephew and niece, Prince George and Princess Charlotte.

An estimated 100,000 people flocked to Windsor and one billion around the world watched on TV.

Meghan's father Thomas Markle missed the wedding as he was recovering from heart surgery.

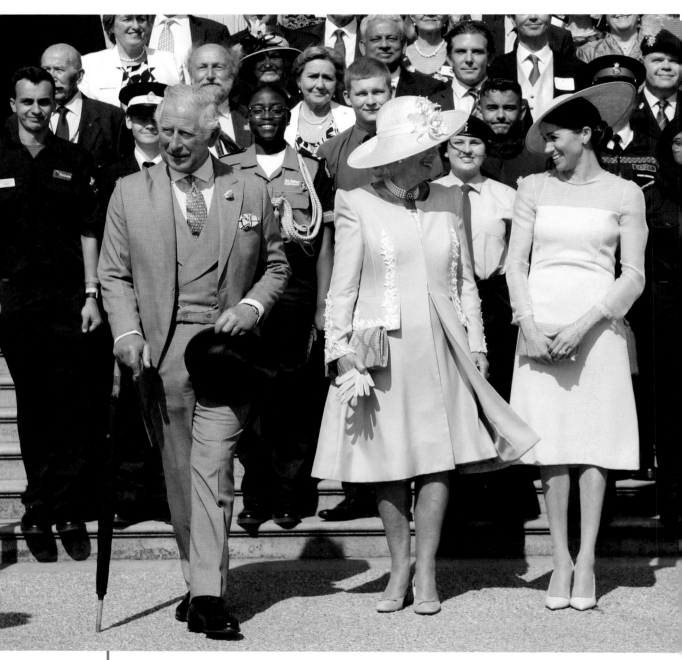

Harry pays a poignant tribute to his father with no sign of the division that was to come.

MY SELFLESS DAD, BY PRINCE HARRY

MAY 22, 2018

Newlyweds Prince Harry and Meghan Markle stole the show at Charles's 70th birthday bash.

The US actress looked regal in a cream hat and matching outfit at her first event as a royal – but made sure to keep her new husband close throughout the afternoon.

The new Duchess of Sussex appeared in high spirits as she smiled and chatted with guests at the Buckingham Palace garden party.

But the couple made sure to keep Charles at the forefront of the event, celebrating his birthday despite the real date actually falling in November.

Newly-married Harry even gave a speech at the birthday party for his dad, paying tribute to Charles for his "selfless drive to affect change".

Speaking to the crowd of thousands, he said: "In my mind this event sums up your approach to work.

"I know you really didn't want today to be about you and would far rather the focus be on the people and organisations represented here.

"I know that in your mind, you see the opportunity of bringing everybody together as a chance to thank them for all the amazing work.

"It is your selfless drive to affect change, whether that is to improve the lives of those who are on the wrong path, to save an important piece of our natural heritage or to protect a particular species under threat, which William and I draw inspiration from every day."

Prince Charles appeared to be proud, but a little embarrassed as he listened to the speech, bashfully tapping his cane on the ground.

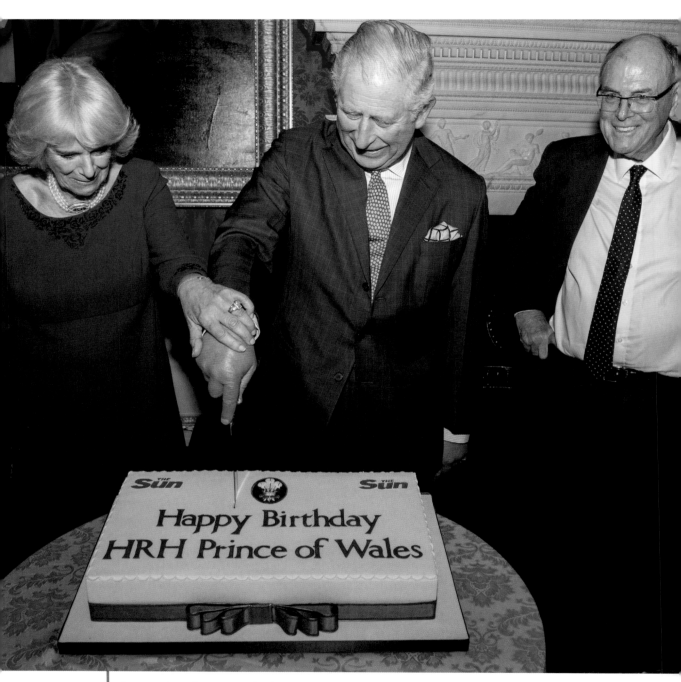

Icing on the cake. Prince Charles cuts our huge treat watched by Camilla and The Sun's Arthur Edwards.

PRINCE AND READERS SHARE THEIR BIG DAY

NOVEMBER 14, 2018

Charles praised *The Sun*'s remarkable readers and our brilliant royal photographer Arthur Edwards for making his 70th birthday "even more special".

The Prince of Wales and wife Camilla joined 70 *Sun* readers, who also reached the landmark age that year, at a party the paper threw for them.

Four were born on the same day as the heir to the throne – November 14, 1948.

As he and the Duchess of Cornwall walked into Spencer House in London, our readers gathered on the steps of the mansion near The Mall and sang Happy Birthday.

Later the Prince told them he was partly responsible for the unique celebrations.

Charles revealed that on a foreign tour, he confided to our Arthur that it would be fun to enjoy reaching the milestone with people who were born on the same day.

Charles added: "So he went away without my knowing and this is the result."

Arthur, who had spent more than 40 years photographing the Prince, launched a competition to find 70 readers who made a real difference in their communities.

And Charles told our winners: "It is an enormous pleasure to see all of you here because I know from Arthur some of the remarkable things all of you have managed to do in your wonderful way, unsung very often, and unseen.

"I admire so much the things that you do in so many special ways.

"Arthur, when I first saw him, used to be crawling about in the undergrowth but it's amazing how life changes!

"He's a very good photographer and a jolly good bloke and a very special person."

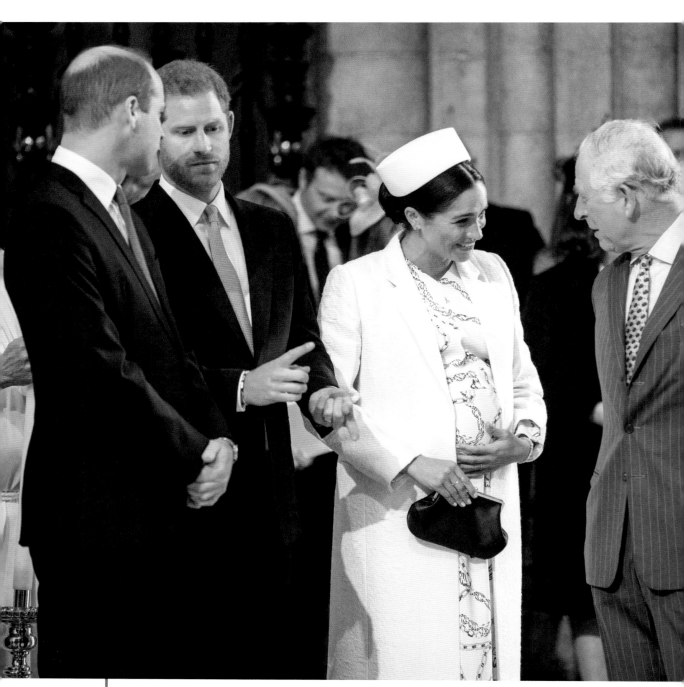

*This was to be Meghan and Harry's last official engagement in Britain.
Archie Harrison Mountbatten-Windsor was born on May 2, 2019.*

FANCY BUMPING INTO YOU, MEG

MARCH 11, 2019

Meghan Markle cradled her baby bump as she smiled with father-in-law Charles at a service to honour the 54 nations of the Commonwealth.

The Duchess of Sussex was due to give birth to her first child in April but tackled the cobbles of Westminster Abbey in her high heels with ease.

The Royal Family marked Commonwealth Day by attending an interfaith service.

In her moving speech, the Queen said: "In this year of my Platinum Jubilee, it has given me pleasure to renew the promise I made in 1947, that my life will always be devoted in service.

"Today, it is rewarding to observe a modern, vibrant and connected Commonwealth that combines a wealth of history and tradition with the great social, cultural and technological advances of our time.

"That the Commonwealth stands ever taller is a credit to all who have been involved."

Meghan looked close to tears as singer Alfie Boe performed an acapella version of Snow Patrol's Run.

The former actress looked Hollywood chic in a white coat and matching pill-box hat, paired with a chain-print silk Victoria Beckham dress, and a clutch purse.

The previous year's event was Meghan's first official engagement with the Queen, making her attendance a year on alongside Prince Harry particularly special. The Duke and Duchess of Cambridge, Prince Charles, and Camilla, Duchess of Cornwall also attended the service alongside the Queen.

SAINT AND GRINNER

OCTOBER 13, 2019

A beaming Pope Francis greeted Prince Charles at the Vatican as he gave Britain its first saint in 45 years.

The 19th-century Catholic Cardinal John Henry Newman was canonised at a ceremony watched by more than 20,000 pilgrims.

In a speech at the college in Rome that Cardinal Newman had attended, Charles praised the churchman for being "able to advocate without accusation, disagree without disrespect and, perhaps most of all, to see differences as places of encounter rather than exclusion."

He added: "These are principles that continue to inspire, and to guide each new generation."

Two Americans claimed to have been miraculously cured after praying to Cardinal Newman. Scottish priest John Ogilvie, executed in 1615, was the last British saint in 1976.

Charles was hosted at the Vatican by Cardinal Vincent Nichols, Archbishop of Westminster.

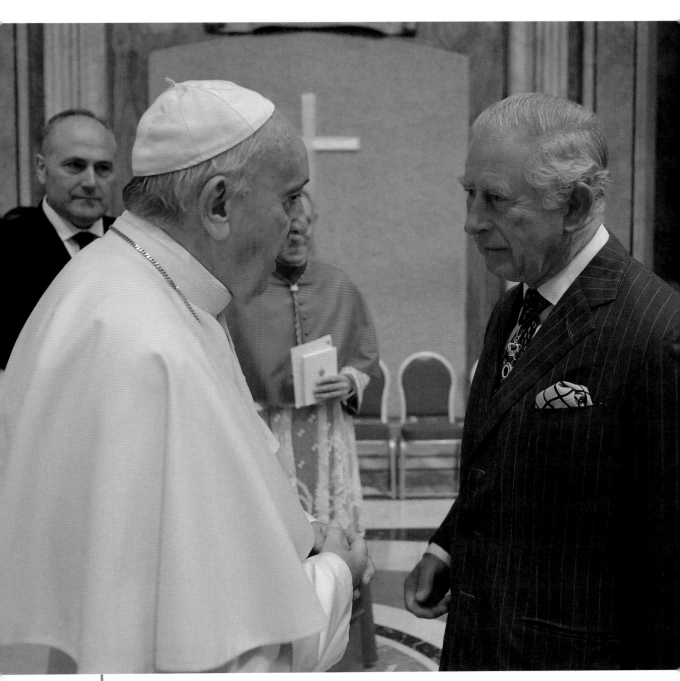

Prince Charles chats with Pope Francis at the Canonisation of Cardinal Newman in the Vatican City.

FEARS FOR HARRY AFTER BRADBY INTERVIEW

OCTOBER 20, 2019

Prince Harry publicly admitted the growing rift between him and his brother Wills, saying: "We're certainly on different paths."

Harry spoke of their strained relationship in an ITV documentary about him and Meghan.

He added: "As brothers, you have good days, you have bad days."

The Sun had told how the simmering tension began when William questioned the speed of Harry and Meghan's engagement.

Meghan told interviewer Tom Bradby, a friend of Harry's, how she tried to adopt a stiff upper lip – but found it "really damaging".

The Duchess of Sussex said her attempt to ignore the media spotlight in the traditional royal manner only caused more unhappiness.

She said she had told Harry it was the wrong approach to take.

She added: "You know, I've said for a long time to H it's not enough just to

survive something, that's not the point of life.

"You've got to thrive; you've got to feel happy.

"And I think I really tried to adopt the British sensibility of a stiff upper lip, but I think what that does internally is probably damaging."

Charles was worried about his youngest son in the same way he used to fear for ex-wife Princess Diana, according to royal sources.

Insiders suggested Charles had supported Harry and Meghan and was said to have felt let down when his daughter-in-law cancelled a meeting with him at the last minute.

However, the future King – who dropped in on the Welsh rugby team in Tokyo – continued to defend them publicly.

A royal source revealed: "The Prince of Wales is very busy at the moment touring Japan, including a visit with the Welsh rugby team. But the point is that this whole kerfuffle has completely undermined the work he is doing, just as it undermined the work Prince William and Kate were doing in Pakistan."

The rift between Charles's sons is made public by Harry's ITV interview shown while his father was on a solo tour of Japan.

DOWN UNDER FOR ANDREW'S DOWNFALL

NOVEMBER 24, 2019

Charles interrupted his royal tour for "stern words" with Prince Andrew.

The future King was in New Zealand as his younger brother stepped down from royal duties after mounting criticism over his friendship with convicted paedophile Jeffrey Epstein.

Charles made a call back to the UK to speak with his brother as the scandal unfolded.

The Prince of Wales was expected to speak again with Andrew when he returned.

The Queen went riding with her second son in a bold show of solidarity, but it was thought Charles would not be so forgiving.

On the other side of the world, the heir to the throne took his mind off family matters while visiting New Zealand's South Island.

He was met with a traditional Maori greeting, then introduced to two llamas, named Legend and Max. He laughed as they were moved into place for a photograph.

Charles was said to have always had a rocky relationship with Andrew – with the latest scandal over his brother's friendship with Jeffrey Epstein making him "bloody furious".

The revelation came days after Andrew gave an interview to BBC2 Newsnight's Emily Maitlis about his links to Epstein.

He strongly denied he had sex with 17-year-old Virginia Roberts in 2001 after going to London's Tramp nightclub, claiming he was at a Pizza Express with his daughter Princess Beatrice.

Royal experts were stunned by the Prince's decision to appear on TV to discuss his billionaire pal Epstein, who died in jail in August, 2019.

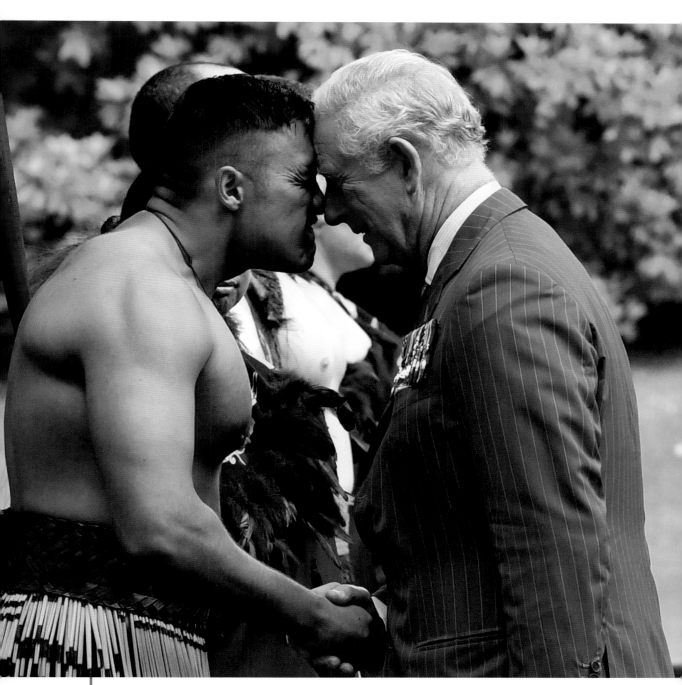

Charles is greeted with a hongi – a traditional Maori welcome as he arrives in Government House, Wellington, New Zealand.

MEGXIT

JANUARY 8, 2020

Harry and Meghan announced on Instagram that they would be quitting as senior royals.

Insiders suggested the Queen was "deeply upset" and Charles and William were "incandescent with rage".

The couple released a bombshell statement revealing they would split their time between the UK and North America.

They said: "We intend to step back as 'senior' members of the Royal Family and work to become financially independent, while continuing to fully support Her Majesty The Queen."

A reported failure to consult other royals was said to have broken protocol.

A senior source claimed their statement had not been cleared with anyone. The insider said it had hurt and disappointed senior royals.

The Queen later put out a statement which said: "Harry, Meghan and Archie will always be much loved members of my family.

"I want to thank them for all their dedicated work across this country, the Commonwealth and beyond, and am particularly proud of how Meghan has so quickly become one of the family."

Later, Harry wrote in his book Spare, that Charles attempted to reconcile his sons, pleading with them at Prince Philip's funeral, saying: "Please boys, don't make my final years a misery."

Prince Harry and Meghan, the Duke and Duchess of Sussex, leave after visiting Canada House.

BACK TO BUSINESS WITH A BOW

JUNE 18, 2020

Namaste.

Charles and the Duchess of Cornwall were back in action amid the pandemic to greet President Macron of France – with a bow not a handshake.

Social distancing guidelines to prevent the spread of Covid-19 meant the traditional royal greeting was out of the question.

Instead the Prince, his wife, Camilla, and Macron used the namaste, traditional Hindu, greeting.

After six decades of shaking thousands of people's hands, Charles had to lose his automatic reflex to reach out. He said: "It's just so hard not to."

The meeting in London marked the 80th anniversary of Charles de Gaulle's "Appel" or broadcast from London, using a BBC microphone, to occupied France after the Nazi invasion.

Macron bestowed the Légion d'Honneur, France's highest distinction, to London to express the country's "infinite gratitude" for support during World War II.

Charles thanked the President in fluent French: "Your presence here today, Mr President, is a powerful demonstration of the bond between our two countries, and between our people, and of our shared determination that it must endure.

"It is a bond forged through common experience, sanctified through shared sacrifice and burnished by the deep affection in which we hold each other."

Charles and Camilla visited Gloucestershire Royal Hospital in the same week, with Charles telling NHS staff he had lost his sense of taste and smell when he caught Covid in March.

In an interview the Prince also raised concerns about the "potentially devastating" impact of lockdown on young people.

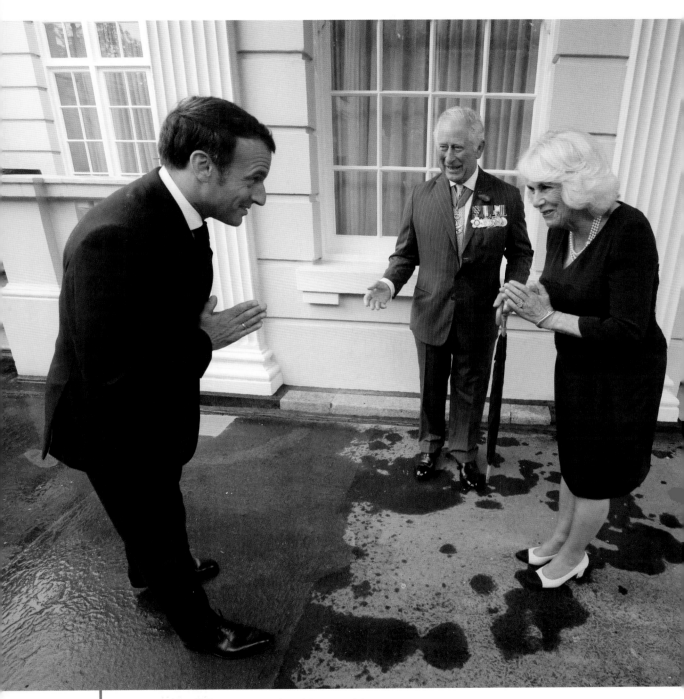

Charles and Camilla meet President Macron with a namaste gesture rather than a handshake to meet Covid regulations.

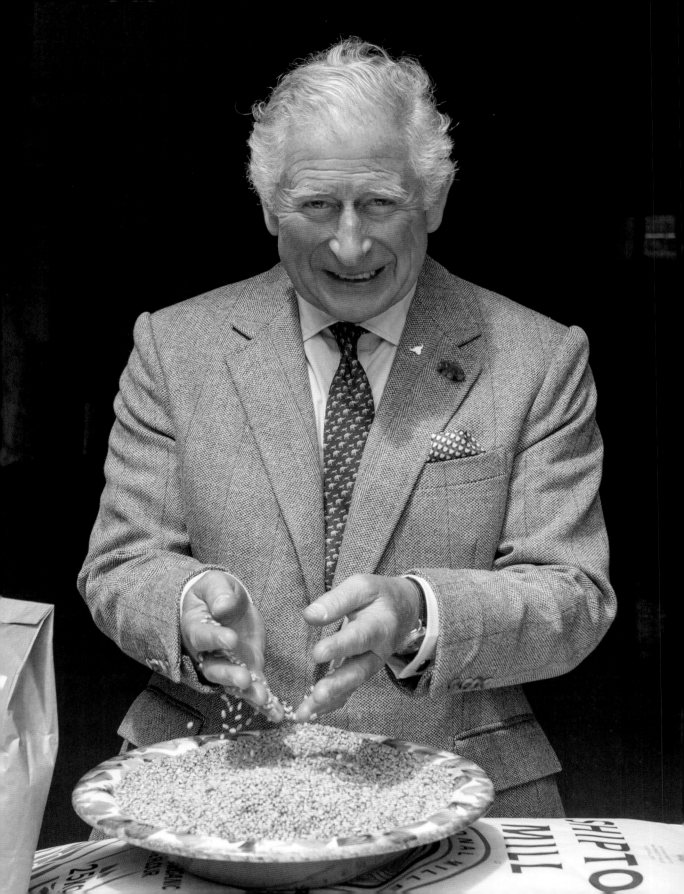

GRAIN OF THRONES

JULY 1, 2020

What's everyone been doing during lockdown? Baking. What do you need for baking? Flour.

Charles visited Shipton Mill, in Long Newton, Gloucestershire, to celebrate their output through the pandemic.

The mill specialises in organic flour and during the first few days of lockdown saw a 25-fold increase in demand. It mills the grain from Charles's own Home Farm in Tetbury.

Shipton was also involved in the early days of the first Duchy Originals products, founded by Prince Charles in the early 1990s and it still helps produce the flour for the range's biscuits.

The Prince asked photographer Arthur Edwards, on his first day back at work after lockdown, how he'd been and agreed it had been a difficult time.

Home Farm is part of the Duchy Estate, established by Edward III and passed down to each heir to the throne. The estate covers 52,449 hectares, stretching from Cornwall across 20 counties mostly in the Southwest of England. Profits go towards charities.

Flour power... Charles at the mill.

CHARLES'S TEARFUL FAREWELL TO PAPA

APRIL 17, 2021

A tear rolled down the cheek of Prince Charles as he bid a final farewell to his Dear Papa.

Grief-stricken Charles was unable to hide his raw emotions as he walked behind Prince Philip's coffin.

For eight agonising minutes, he led the procession of royals on foot as the Duke of Edinburgh made his final journey on the back of a green Land Rover.

Charles was flanked by his sister Princess Anne, and followed by Princes Andrew, Edward, William and Harry as the coffin made its way to St George's Chapel.

Despite a sometimes difficult relationship with his father, Charles's grief was clear to millions around the world. He struggled throughout the procession and the service to hide his clear personal loss. Each minute was marked by gunfire as the band of the Grenadier Guards – of which the Duke was colonel for 42 years – played.

Inside the chapel, Charles, wearing a black morning suit, sat opposite the Queen as they both gazed at the coffin, separated in line with Covid restrictions.

Philip abhorred fuss and often joked with the Queen when discussing the arrangements: "Just stick me in the back of a Land Rover and drive me to Windsor."

He got his wish but members of the Armed Forces, of which he was so closely linked, gave him a fitting send-off beneath the blue skies and splendid sunshine of Windsor.

At the start of the service, a laurel wreath was placed in Philip's choir stall next to the Queen – replacing his banner, helm, mantling and sword.

The royals sat two metres apart as the doors to St George's Chapel were then closed and the Royal Navy Piping Party piped the Carry On.

The 50-minute service was written by the Duke and celebrated his life at sea. Nautical tributes included the hymn Eternal Father, Strong to Save, traditionally associated with seafarers and maritime armed services.

The Queen was first to leave the chapel, followed by Charles and other family members who made their way back into Windsor on foot.

The Duke of Edinburgh passed away on April 9, 2021 – two months short of his 100th birthday.

Charles leads his family as they follow Prince Philip's coffin during the ceremonial procession.

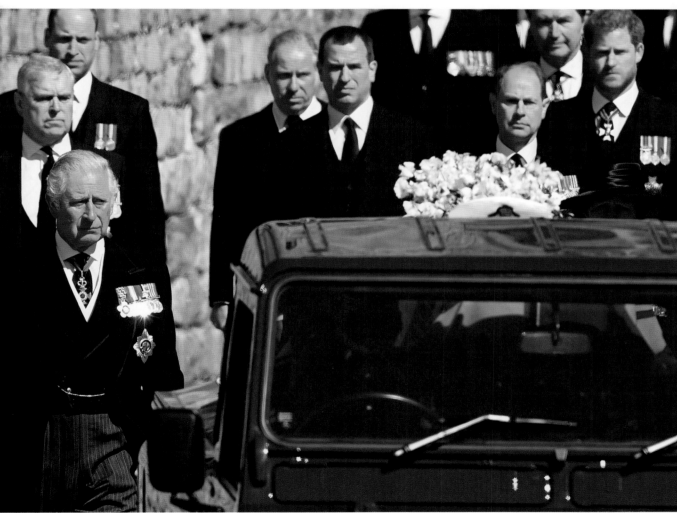

CLOSE BOND WITH KATE

SEPTEMBER 28, 2021

Kate Middleton and Prince Charles showed a very close bond at a star-studded 007 premiere.

The Duchess of Cambridge and her father-in-law hugged as they arrived at the new James Bond film No Time To Die, with Kate kissing the future King on the cheek.

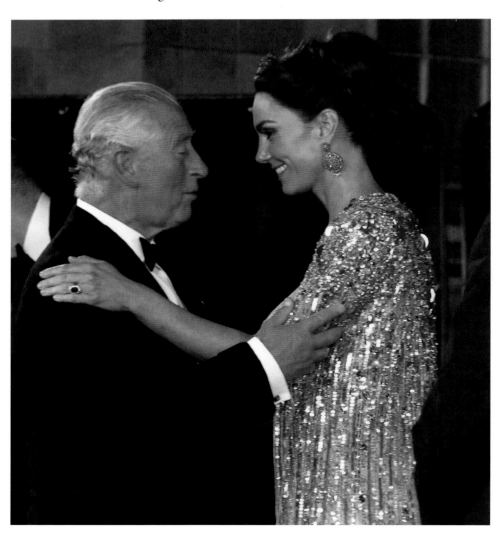

Prince Charles and his daughter-in-law share a close and mutually supportive relationship.

In a rare joint engagement at the Royal Albert Hall in London, Charles, Camilla, William and Kate stepped out on the red carpet to meet star Daniel Craig, scriptwriter Phoebe Waller-Bridge and singer Billie Eilish, who co-wrote the film's theme song.

A number of healthcare workers and members of the Armed Forces joined the royals to watch the movie as a thank you for their work during the Covid pandemic.

The Duchess and the Prince of Wales are very close. She calls him "Pa" and they often laugh at each other's jokes when in public.

The next generation including Leonardo Di Caprio and Stella McCartney pick up on Charles's early passion for environmentalism.

LEO, STELLA AND A WARNING OVER CLIMATE CHANGE

NOVEMBER 3, 2021

Fast fashion is destroying the planet, Stella McCartney told Prince Charles and actor Leonardo Di Caprio.

The fashion designer was exhibiting her leather-free shoes at Glasgow's Kelvingrove Museum for the COP26 conference on climate change.

In a hard-hitting address at the opening ceremony, the Prince told delegates that leaders and nations must work together to reduce emissions and tackle carbon already in the atmosphere.

He said: "Many of your countries I know are already feeling the devastating impact of climate change, through ever-increasing droughts, mudslides, floods, hurricanes, cyclones, and wildfires.

"Any leader who has had to confront

such life-threatening challenges knows that the cost of inaction is far greater than the cost of prevention."

Charles also delivered a speech on climate change the previous day to the G20 summit in Rome.

There he warned that the COP26 conference was "quite literally the last-chance saloon" to tackle climate change, and that there was an "overwhelming responsibility to generations yet unborn"

to agree on how to reach Net Zero.

The Queen had been due to host a reception at COP26 for world leaders but had to pull out on the advice of her doctors. Instead, she recorded a video message.

The Prince of Wales was joined at the conference by the Duke and Duchess of Cambridge as well as dignitaries from around the world, including US President Joe Biden.

HEALTH FEARS FOR HER MAJESTY

NOVEMBER 14, 2021

Amid the sombre reflection for the fallen, Britain's Armed Forces sent a get-well message to the Queen.

As they gathered in Whitehall waiting for the traditional two-minute silence at 11am, whispered words spread among the 10,000 who fought for Queen and country that their sovereign was too ill to attend this year.

So, after Charles and other members of the Royal Family had laid their wreaths for the nation's glorious dead, the huge crowd sang God Save the Queen louder and with more gusto than ever before.

World War II radar operator Leonard Hobbs, 97, said: "It was as if they were singing for the Queen to get better. She has been a good Queen and I hope she gets better soon."

Former Warrant Officer Colin Veal, who served in Northern Ireland, the Gulf, Bosnia, and Afghanistan, said: "God Save the Queen was all the more poignant because she wasn't there.

"When I joined the Army in 1974, the Queen was the boss. I'm a veteran now and she's still the boss." Colin, of Coalville, Leicestershire, added: "To every one of us who have served Queen and country, there's something special about having her here.

"It is not the same without her."

The Queen's place in the centre balcony of the Foreign Office was taken by the Duke of Kent. To the Duke's left, Camilla, Kate and Sophie watched on as Prince Charles, looking tired in his naval uniform, laid the Queen's wreath on behalf of the nation.

Charles lays wreath on behalf of the Queen.

Friends as well as in-laws, the Queen, accompanied by the Duchess of Cornwall, visits Ebony Horse Club and Community Riding Centre, Brixton, London, October 2013.

CAMILLA ANNOINTED

FEBRUARY 5, 2022

Charles and Camilla led tributes to Her Majesty as she marked 70 years on the throne – the Prince telling of the honour that his "darling wife" would be the next Queen.

The monarch had used her Accession Day address to anoint Camilla as Queen Consort when her eldest son took her place.

In the message issued from Sandringham, Her Majesty declared: "When, in the fullness of time, my son Charles becomes King, I know you will give him and his wife Camilla the same support that you have given me; and it is my sincere wish that, when that time comes, Camilla will be known as Queen Consort as she continues her own loyal service."

Charles said: "We are deeply conscious of the honour represented by my mother's wish.

"As we have sought together to serve and support Her Majesty and the people of our communities, my darling wife has been my own steadfast support."

In a written address, the Prince added: "My wife and I join you all in congratulating Her Majesty on the remarkable achievement of serving this nation, the Realms of the Commonwealth for 70 years."

"Queen Consort" refers to the spouse of a ruling king and meant "Queen Camilla" would be her future title.

There had been suggestions Camilla would be known as Princess Consort because of uncertainty about public opinion after the death of Princess Diana.

The Queen's declaration put paid to that.

A Clarence House spokesperson said the Prince of Wales and Duchess of Cornwall were "touched and honoured".

GOD SAVE THE QUEEN

JUNE 5, 2022

The Queen delivered a final Platinum Jubilee surprise with her third balcony appearance to bring down the curtain on a momentous four days.

Her Majesty, 96, thrilled thousands of flag-waving revellers outside Buckingham Palace as she stood alongside her family.

And her Majesty got her own shock when a barrage of red, white and blue fireworks exploded in her honour.

As they went off, she was seen to say: "Ah brilliant, I didn't know."

The Queen thanked millions around the world who had joined the party – and reaffirmed her commitment to the nation in a stirring message.

Signed Elizabeth R, she wrote: "When it comes to how to mark seventy years as your Queen, there is no guidebook.

"It really is a first. But I have been humbled and deeply touched that so many people have taken to the streets to celebrate my Platinum Jubilee."

As the jubilee pageant finished on The Mall, thousands streamed around the Queen Victoria Monument.

At the same time Prince Charles, Camilla, Prince William, Kate and Princess Charlotte left their royal box in the stands to move to the Buckingham Palace balcony.

Ed Sheeran performed his hit Perfect as footage of the Queen and Prince Philip appeared on a screen behind him.

Then, the crowd erupted with cheers as the Queen slowly and steadily emerged from the Buckingham Palace royal balcony, aided by her walking stick.

Charles gave "Mummy" a gentle hand on her left elbow.

After a final glance at vast crowds, she gestured to her family and turned to go back inside. Charles was again seen to give her a helping hand.

Earlier in the Jubilee celebrations, Prince Louis had stuck his tongue out, roared with approval and played musical chairs in the royal box at the pageant. The four-year-old left his seat to finally settle on Grandad Charles's knee.

*Prince Louis covers
his ears during the
Platinum Jubilee
flypast.*

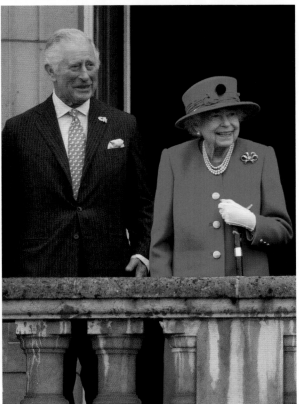

*The last time Queen Elizabeth
was photographed in public
with her son and heir.*

Charles follows behind the coffin, draped in the Royal Standard with the Imperial State Crown and the Sovereign's orb and sceptre, as it is carried out of Westminster Abbey.

King Charles III, a picture of his mother beside him, addresses the public for the first time.

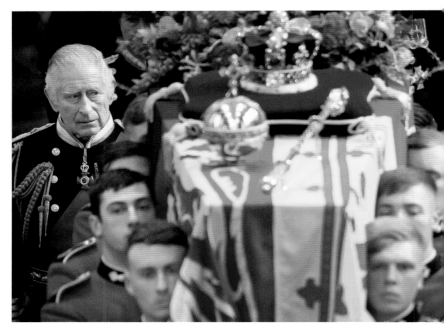

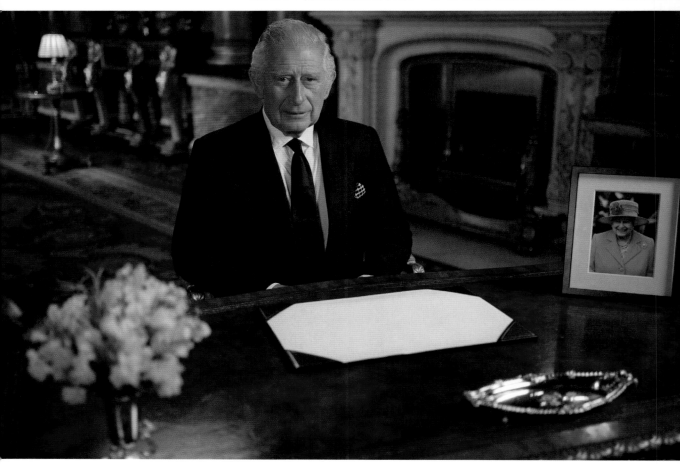

MAY FLIGHTS OF ANGELS SING THEE TO THY REST

SEPTEMBER 9, 2022

King Charles III pledged his lifelong service to the nation and spoke of his profound sorrow at the loss of his "darling Mama".

In a highly emotional first televised address to the nation, he hailed his mother's "warmth, humour and unerring ability always to see the best in people."

He praised her "life well-lived", her "sacrifices for duty" and "unswerving devotion".

He ended the nine-minute address: "I want simply to say this: Thank you." He added poignantly: "May flights of angels sing thee to thy rest."

The King spoke from Buckingham Palace's Blue Drawing Room, minutes after arriving with wife Camilla.

Confirming her new title Queen Consort, he said: "I know she will bring to the demands of the new role the steadfast devotion to duty on which I have come to rely so much."

He said William and Kate would become Prince and Princess of Wales, the latter becoming the first to hold the title since Diana.

And in an olive branch to his younger son, Charles III expressed his love for Harry and Meghan "as they continue to build their lives overseas."

The new monarch began his speech by speaking of his profound sorrow at the loss of his mother who died at Balmoral Castle aged 96.

He recalled the Queen's pledge on her 21st birthday in 1947 that she would "devote her life, whether it be short or long, to the service of her peoples."

Charles vowed the same "throughout the remaining time God grants me."

He told Britain and the Commonwealth: "I shall endeavour to serve you with loyalty, respect and love, as I have throughout my life."

LIKE MOTHER LIKE SON

SEPTEMBER 9, 2022

Sun photographer Arthur Edwards offered his condolences to King Charles and the monarch replied: "It had to happen one day."

Arthur was at the bottom of the steps at RAF Northolt when he arrived from Balmoral.

The King was captured on TV cameras leaning in to speak to Arthur at the West London air base.

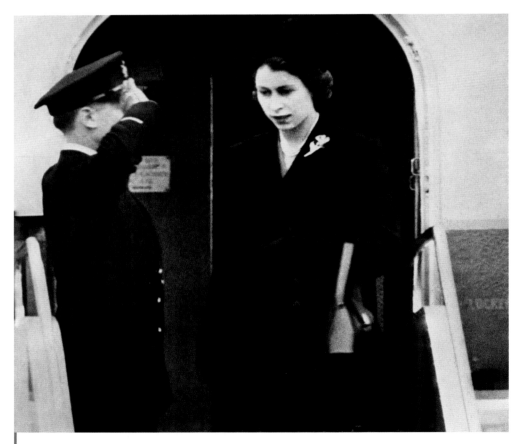

Queen Elizabeth arriving at London Airport after the death of her father, King George VI.

Arthur said: "I have been photographing this man for more than 40 years.

"I feel so deeply sorry for him because it is a terrible thing to lose your mother, for anyone.

"So, I said, 'I am sorry for your loss.'"

Arthur noted the remarkable similarity between the picture he had taken of the new King and the historical shot of Queen Elizabeth arriving at London Airport (now Heathrow) from Kenya on February 7, 1952, following the death of King George VI and her accession to the throne.

The 27-year-old Queen was met by Prime Minister Winston Churchill and opposition leader Clement Attlee.

The new King.

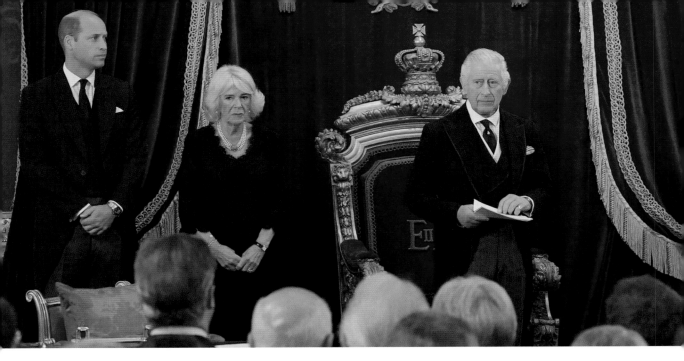

ALL HAIL THE KING

SEPTEMBER 10, 2022

History was made as Charles was proclaimed King in the first TV ceremony of its kind.

The secret rituals of the 419-year-old Accession Council were broadcast for the first time.

The proclamation was followed by three cheers by the King's Guard outside St James's Palace, and a rendition of God Save The King.

As he was formally declared King Charles III at the palace, the new monarch described the late Queen's reign as "unequalled in its duration, its dedication and its devotion."

And he praised Queen Consort Camilla, saying he was "profoundly encouraged by the constant support of my beloved wife."

Two cameras captured the ceremony. A hushed silence fell in the 486-year-old palace as the new King entered the Throne Room with his son William, the new Prince of Wales, and Camilla.

Lord President of the Privy Council Penny Mordaunt opened the proceedings.

The King, 73, then paid tribute to his mother and the "irreparable loss we have all suffered."

He said: "It is the greatest consolation to me to know of the sympathy expressed by so many to my sister and brothers, and that such overwhelming affection and support should be extended to our whole family in our loss.

"To all of us as a family, as to this kingdom and the wider family of nations of which it is a part, my mother gave an example of lifelong love and of selfless service.

"My mother's reign was one unequalled in its duration, its dedication, and its devotion. Even as we grieve, we give thanks for this most faithful life.

"I am deeply aware of this great inheritance and of the duties and heavy responsibilities of sovereignty which have now passed to me."

He added: "In taking up these responsibilities, I shall strive to follow the inspiring example I have been set in upholding constitutional government and to seek the peace, harmony, and prosperity of the peoples of these islands and of the Commonwealth realms and territories throughout the world.

"In this purpose, I know that I shall be upheld by the affection and loyalty of the peoples whose sovereign I have been called upon to be, and in the discharge of those duties I will be guided by the counsel of their elected parliaments.

"In all this, I am profoundly encouraged by the constant support of my beloved wife.

"I take this opportunity to confirm my willingness and intention to continue the tradition of surrendering the hereditary revenues, including the Crown Estate to my government for the benefit of all, in return for the Sovereign Grant, which supports my official duties as head of state and head of nation.

"And in carrying out the heavy task that has been laid upon me, and to which I now dedicate what remains to me of my life, I pray for the guidance and help of Almighty God."

For the first time he used a new signature for the declaration – writing Charles R – and wore a tie pin with the initials "CR".

At one stage he grimaced and asked an aide to remove a tray of pens to give him more room.

More than 200 privy councillors witnessed the declaration. Among them were six former Prime Ministers: Sir John Major, Sir Tony Blair, Gordon Brown, David Cameron, Theresa May and Boris Johnson. New PM Liz Truss stood at the head of the council with Camilla, William, Archbishop of York Justin Welby and other figures.

Following convention, His Majesty did not attend the first part of the ceremony when the clerk of the council Richard Tilbrook read the proclamation.

He said: "Prince Charles Philip Arthur George is now, by the death of our late sovereign of happy memory, become our only lawful and rightful liege lord, Charles III."

Charles had been born a stone's throw away, at Buckingham Palace in 1948. After 73 years of the most eventful life and devoted service to the nation and Commonwealth, his journey to the throne was complete.

God save the King.

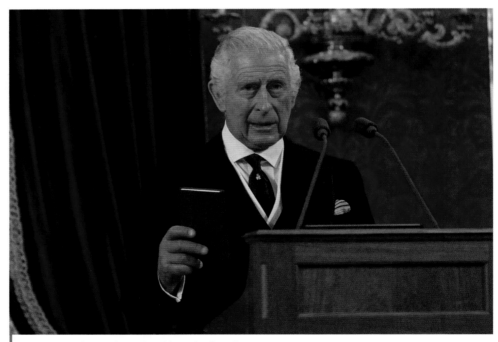

The King takes oath with Bible in his hand.